PEGASUS
Library

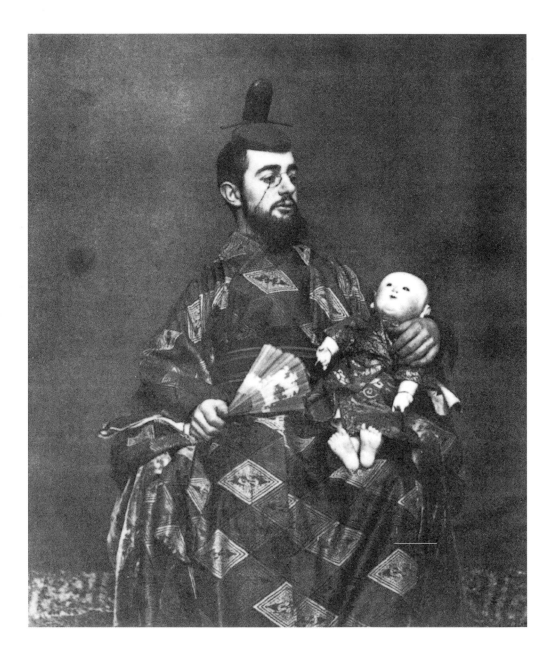

Reinhold Heller

Toulouse-Lautrec

The Soul
of Montmartre

Prestel

Munich · New York

Front cover: *Yvette Guilbert saluant le public* (*Yvette Guilbert Greeting the Audience*), 1894, detail; see p. 84
Spine: *La Loge au mascaron doré*, (*The Box with the Golden Mask*), 1893, detail, color lithograph, Museum of Art, New York, Gift of Clifford A. Furst, Delteil 16

Frontispiece: Henri de Toulouse-Lautrec in Japanese costume, *c.* 1892, photograph by Maurice Guibert, Bibliothèque Nationale, Paris

Page 5: Portrait with walking stick, drawing, Musée Toulouse-Lautrec, Albi; Dortu D. 2900

© for picture on cover and on page 84, Museum of Art, Rhode Island School of Design, Bequest of Mrs. Murray S. Danforth
© Photographie Giraudon, Vanves, for photographs on pages 6, 14, 36, 94 (Lauros-Giraudon); pages 62-63, 79, 96-97 (Bridgeman-Giraudon); page 100 (Giraudon)
© for all other pictorial material: Prestel archive

Library of Congress Cataloging-in-Publication Data
Heller, Reinhold. Toulouse-Lautrec : The Soul of Montmartre / Reinhold Heller. p. cm. — (Pegasus Library)
ISBN 3-7913-1739-3 (English ed. : acid-free paper). — ISBN 3-7913-1792-X (German ed. : acid-free paper)
1. Toulouse-Lautrec, Henri de, 1864-1901—Criticism and interpretation. 2. Paris (France)—Intellectual life—19th century. 3. Montmartre (Paris, France)—Intellectual life. I. Title. II. Series.
ND553.T7H39 1997
759.4—dc2197-3739

Manuscript edited by Andrea P.A. Belloli, London

© 1997, Prestel-Verlag, Munich · New York
Prestel-Verlag
Mandlstrasse 26 · 80802 Munich · Germany
Tel. (+49 89) 38 17 09 0; Fax (+49 89) 38 17 09 35
and 16 West 22nd Street, New York, NY 10010, USA
Tel. (212) 627 8199; Fax (212) 627 9866

Prestel books are available worldwide.
Please contact your nearest bookseller or write to either of the above addresses for information concerning your local distributor.

Designed by WIGEL, Munich
Lithography by ReproLine, Munich
Printed and bound by Passavia Druckerei GmbH, Hutthurm

Printed in Germany

ISBN 3 7913 1739 3 (English edition)
ISBN 3 7913 1792 X (German edition)

Printed on acid-free paper

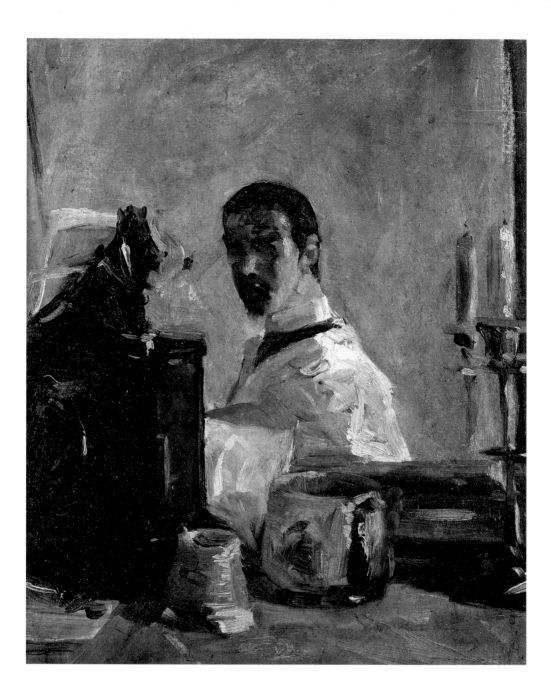

This much is certain: *Au Moulin Rouge*, justifiably one of Henri de Toulouse-Lautrec's most famous and admired paintings — his biographer, Maurice Joyant, characterized it as "one of the most important of all works by Lautrec ... the summation of all his studies of the Moulin Rouge ..."[1] — at one time was sliced into two separate pieces, and one part was discarded. One of these pieces was rectangular and turned into an independent painting, focused on the group of three men and two women seated around a table in a room at the Moulin Rouge dance hall. The other fragment was shaped like a reversed *L*, with the vertical section containing the single figure of the right-hand woman and the horizontal retaining random bits of chair legs and railing cut from the separated rectangle; it was neatly folded and stored away, hidden while its companion piece was exhibited, photographed, and publicized. The acts ironically combine blatant but covert vandalism and subtle but public falsification of the painting. Apparently, they were performed by executors of Toulouse-Lautrec's estate during the spring of 1902, only a few months after the artist died.[2]

Au Moulin Rouge was among the works that Toulouse-Lautrec left to his father and that Alphonse-Charles-Jean-Marie, Count of Toulouse-Lautrec Montfa, then ceded "with all my heart and without regret ... [because] you believe in this work more than I do ..." to Joyant, co-owner of the Parisian art gallery of Manzi-Joyant. The donation was, in a sense, the aging aristocrat's final resigned rejection of the decadent bohemian and artistic world that his son had reconfigured into his art, the world of the Moulin Rouge and of Montmartre, and that represented in turn a perhaps forced substitution by the son for the aristocrat's favored world of horses, hunting, riding, and other robust, "manly" outdoor activities. The paintings of the mourned son had no place among the values of the surviving father.

In a book on falconry he gave to his son in 1876, the count inscribed a concise summation of these values as admonition and advice:

PORTRAIT DE LAUTREC DEVANT UNE GLACE,

c. 1882–83

(Self-Portrait in Front of a Mirror)

oil on cardboard, 15 7/8 × 12 3/4 in.

(40.3 × 32.4 cm)

Musée Toulouse-Lautrec, Albi; Dortu P. 76

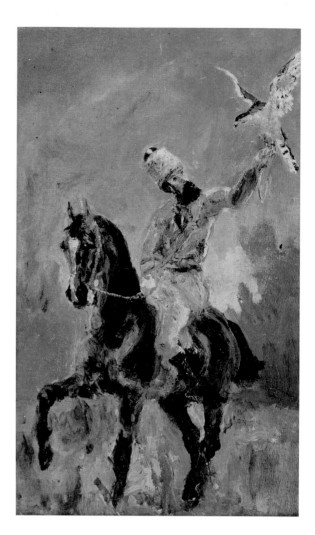

Remember my son, that the only healthy life is life in the out of doors and in the light of the sun; everything deprived of liberty soon degenerates and dies ... Should you one day experience the bitterness of life, dogs and falcons and, above all, horses will be your faithful companions and help you to forget a little.[3]

Toulouse-Lautrec's biographers like to point to the irony of this inscription written just two years before he broke his legs and was rendered physically incapable of following his father's advice to ride, hunt, and keep falcons. These activities, however, also define a style of life for a landed aristocracy that had become an anachronism in the society

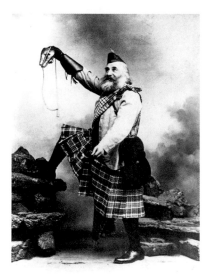

of France's Third Republic. Although avidly supporting hopes for a royalist restoration, non-purposive pleasures were its major remaining interest, defining an existence without labor that preserved an apparently superior separation from the remainder of society and accented "life in the out of doors" as testimony to overt physical health and strength, the proffered antithesis to widespread perceptions of a degenerate, genetically inferior, and weakened social class.

Nonetheless, the making of art was a significantly treasured practice in the noble family that traced its ancestry back to the time of Charlemagne. "When my sons kill a woodcock," the count's mother is said to have observed, "they enjoy it three ways: in the shot of the rifle, in the jab of the fork, and in the stroke of a pencil."[4] Drawing and watercolor, oil painting, and modeling in clay in small scale were indeed favored pastimes for her sons and then also for her young grandson. But the enjoyments itemized by the grandmother significantly exclude both cleaning and cooking the fowl, tasks that are more mundane and purposive, that indeed were classified as work or toil rather than enjoyment in the context of the aristocratic household; they were delegated to servants and cooks. The pleasures of the aristocrats and the activities in which they engaged were denied purposiveness and served instead as the means of filling time, of preventing boredom and idleness.

When he was bedridden and was shuttled by his mother from one spa to another in a futile search for cures — including a miraculous one at Lourdes — for his fragile legs, Toulouse-Lautrec continued the practices of his family. He sought release from the entrapment of enforced inactivity in drawing and painting. "I am all alone the entire day," he complained. "I read a little, but after a while my head hurts. I draw and I paint so much that my hand grows tired ..."[5] Caricatures that are, surprisingly, gently humorous in their distortions abound among the images he made, but his favored subjects — and the motifs of his first oil paintings — were horses, hunts, and other equestrian themes. He replicated the thematic repertoire of *peintres animalier* and *peintres sportif* who specialized in representations of the propertied gentry at leisure, but he

Count Alphonse de Toulouse-Lautrec,
father of the artist, in Scottish dress
Photograph
Bibliothèque Nationale, Paris

also offered an enthusiastic celebration in his still amateur art of the masculine aristocrat's "life in the out of doors" from which he was now excluded. The motifs of his art replaced a life that had been. As they depicted the son's contemporary witnessing of his father's equestrian activities, they were a melancholy recollection of the past even if they perhaps also embodied a hope for a future of restored health, permitting a resumption of the activity now limited to artistic representation.

Precisely when Toulouse-Lautrec ceased to see art as an aristocratic pastime, or as a mediocre substitute for the activity depicted, and instead sought to become a professional artist is unclear. He had had lessons from time to time from the *peintre animalier* René Princeteau, and he received these more consistently and in Princeteau's Paris studio after 1879. But there is nothing to indicate that this was more than an effort to perfect the skills of a hobby, much as he made more consistent efforts than previously to collect stamps as he recuperated from his falls. Indeed, his desire in 1881, after passing his baccalaureate, to study with the well-known painter Cabanel and to begin Academic training at the Ecole des Beaux-Arts may still have been motivated by a wish to increase amusing skills, although when he wrote to his uncle about these plans, he also indicated that "Papa understands none of this."[6] What "Papa" did not understand, it seems to me, was not the paintings of the "sporting life" his son produced under Princeteau's tutelage, as is commonly thought, but rather the willingness and desire to enter the Academy as a student. This represented not only a willingness to give up "liberty" but also the preference of values other than those espoused by the landed gentry and provincial aristocracy with their accented life of leisure. Students at the Ecole and the studios associated with it trained for a trade, were not engaged in an amusing amateurish pursuit of art as pastime, and intended to practice art purposively as a profession. To become professional artists, in short, demanded the production of wares to be sold, the practice of commerce as well as directed toil and labor. It denied the prioritizing of leisure and purposiveless "liberty" which marked the privilege of the aristocratic class. Implicitly, too, it approached a rejection of aristocracy itself as it embraced

LA COMTESSE NOIRE

(The Countess in Black), 1880

graphite on ivory wove sketchbook paper

6 $^1/_4$ × 10 $^1/_8$ in. (16 × 25.7 cm)

The Art Institute of Chicago,

Robert Alexander Valler Collection

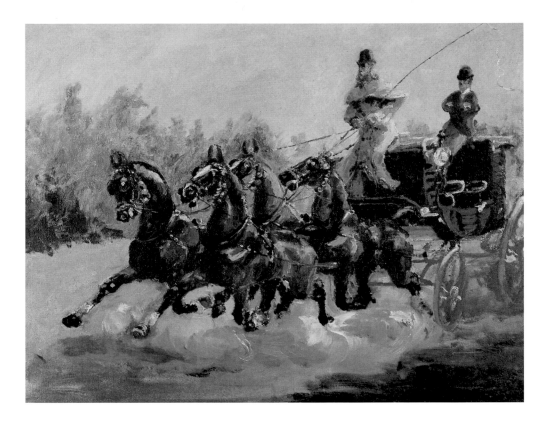

equality in artistic competition, a denial of the privileges of birth. Here was an aspect of his son's ambitions which the father clearly could neither understand nor fully condone.

Toulouse-Lautrec did not enter the Academy, but instead joined the studios, initially of Léon Bonnat, then of Fernand Cormon in 1882. The next year, he exhibited his work to the public for the first time — a small painting at the Société des Amis des Arts in Pau — thereby placing himself in competition among the rank of professional painters. He did so, however, by using only his family name in one of its variant spellings, Henri Montfa, thus disguising his aristocratic identity lightly but sufficiently to keep it hidden from most of the public. The gesture may well have been intended to counter paternal and family misgivings. The ancient name and house of the de Toulouse-Lautrec Montfa family therefore did not enter the modern egalitarian commercial and artistic milieu of the exhibition. Aristocracy and the trade of artist remained separate. What

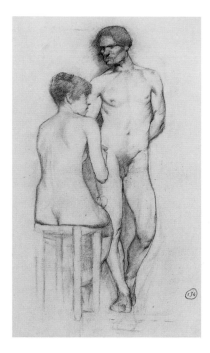

COUPLE NU, FEMME ASSISE (ACADÉMIE),
1883–87
(Nude couple, Woman Seated
— Figure Study)
charcoal and graphite, 24 $7/8$ × 19 $1/4$ in.
(63 × 49 cm)
Musée Toulouse-Lautrec,
Albi; Dortu D. 2.579

I find even more significant is that at this point the shift from aristocratic amateur to practicing professional artist, although still in training, was completed, and Toulouse-Lautrec took on an identity separate from father, family, and historical aristocratic precedent.

He submitted totally to the Academic training offered by his teachers, with its principle emphasis on draftsmanship, beginning by drawing after plaster casts, graduating to representations of the nude model, and then turning to painted compositional sketches that re-flected the romanticized reconstructions and allegories of prehistoric and medieval life favored by his teacher Cormon.[7] His success at meeting the criteria of the studio is indicated by Cormon's wish that he collaborate with a group of well-known Academic Realist artists in illustrat-ing the commemorative edition of Victor Hugo's works, and Cormon's wish that he serve as *massier*, or overseer, of his studio. Neither of these two marks of Academic achievement reached their desired culmination — the one because the publisher did not accept Toulouse-Lautrec's drawings, the other because he turned down the "irksome post" — but they accent how fully he met and submitted to the discipline of approved Beaux-Arts training.

Cormon's teaching practices also permitted his students significant independence, however. With other students from the studio, Toulouse-Lautrec painted por-traits out-of-doors in accordance with Naturalist *plein-air* methods and continued these efforts during summers spent at his family's Céleyran estate. His portrait of his mother (see p. 14), for example, shows a significantly lighter palette than works produced for Cormon, but the broadly applied brush strokes of thinned paint with their cross-hatched, zigzagged, and scumbled, seemingly random patterns continue to recall techniques of drawing learned in the studio now shifted into a different medium and a more monumental format. Technique and stiffness of posture are indicative of a painter in formation. An early if knowledgeable and ambitious effort, this portrait shows the countess clothed in white and seated at a table, a white coffee cup resting on its polished surface, while bright white light filters through the white curtains of

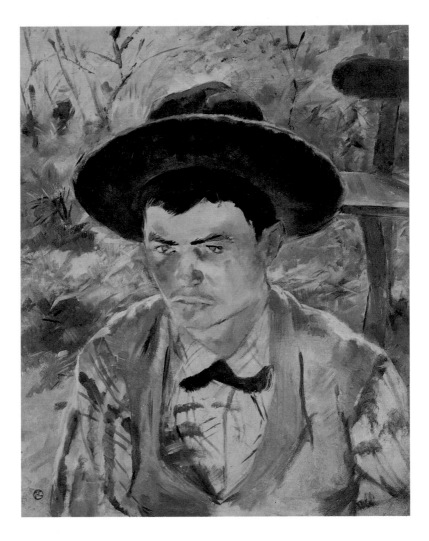

LE JEUNE ROUTY À CÉLEYRAN, C. 1883
(The Young Routy in Céleyran)
oil on cavas, 24 × 19 ⁵/₈ in. (61 × 49.8 cm)
Bayerische Staatsgelmäldesammlungen,
Neue Pinakothek, Munich; Dortu P. 150

a window behind her, transforming all colors into pale white-influenced versions of themselves, and the scene into a chromatic study of muted whites. Along with paintings of workers at Céleyran and several essays in landscape, the portrait of his mother emulated the *plein-air* Naturalism of artists such as Jules Bastien-Lepage or even the earlier Barbizon painters, a highly praised mode of painting progressive in its connotations but avoiding such stylistically innovative radicalism as was practiced by the Impressionists. It pushed beyond the practices of the Academy, but remained an acceptable stylistic vocabulary for exhibition and the receipt of awards at the official Salons. In accordance with his new artistic prototypes, there was

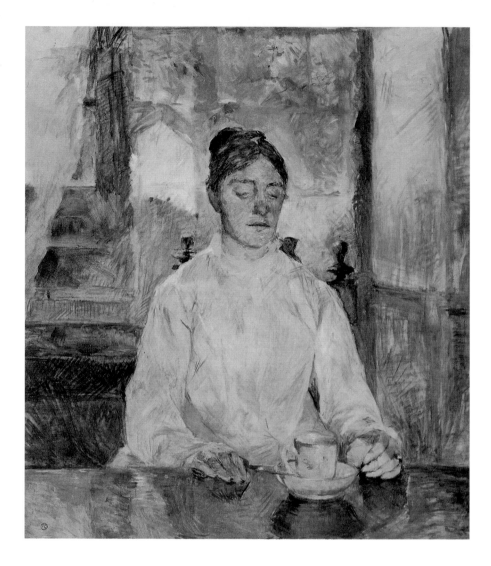

also a shift in Toulouse-Lautrec's subject matter from out-door activities of the aristocracy to the mundane existence of agricultural workers and scenes of everyday life.

The shifts in Toulouse-Lautrec's style and subject matter were products of his maturing persona as an artist and of the experimentation, still tentative and cautious, that accompanied it. They surely also connote further distancing from his father and family, with the major exception of his mother. In his letters at this time, he in-dicates on several occasions that his relationship with his

COMTESSE A. DE TOULOUSE-LAUTREC, C. 1883
(Countess A. de Toulouse-Lautrec)
oil on canvas, 36 3/4 × 31 7/8 in.
(93.5 × 81 cm)
Musée Toulouse-Lautrec, Albi; Dortu P. 90

Countess Adèle de Toulouse-Lautrec,
mother of the artist

father was cool and distanced and that the count, like much of the remainder of the family, showed little understanding about, and significant animosity toward, his career choice. With a mixture of gratitude and regret, he wrote to his mother: "I am happy that what I do brings you some degree of satisfaction ... This obstinacy with which the majority of the family ridicules me bothers me a lot."[8] The support and concern his mother gave him, her hopes for his future and success as well as her prayers for him at daily mass, should then also be seen as motivations for his portrait of her, as an application of newly formed skills in an homage to her much as previously he admiringly had painted his father, who now fell totally from the repertoire of portraits. To continue in his training as a professional artist meant further alienation from his family and class. This was accompanied by ambivalence and some hesitation, a desire for acceptance and approval from his social equals, but their rejection simultaneously inspired his rebellious determination to continue and to succeed at the profession they found offensive and demeaning.

The patterns of his friendships and activities as of 1884 confirm the shift in Toulouse-Lautrec's loyalties. He spent his days at Cormon's studios, accepting instruction and direction, and painting out-of-doors with his fellow students in the afternoons, leaving little free time for other activities. "Not a minute, not an instant to myself," he complained with humorous irony to a cousin. "You did well never to deliver yourself to painting. It is as difficult as Latin if one takes it seriously! And that is precisely what I am trying to do."[9] His preferred companions were the artists he met at the studio. The time and experiences shared with them replaced those formerly shared with his own family and members of the landed gentry. To an extent, this may simply reflect Toulouse-Lautrec's increasing maturity — he was now twenty years old — and an adult independence, but for him it necessarily also involved shifts precisely in his social identity such as to diminish the privileges and prejudices according to which he had been raised. Shared experience and identity are a major component of the homage-parody of Puvis de Chavannes' prize-winning painting *Le Bois sacré* painted jointly by Toulouse-Lautrec and other Cormon students, and indeed

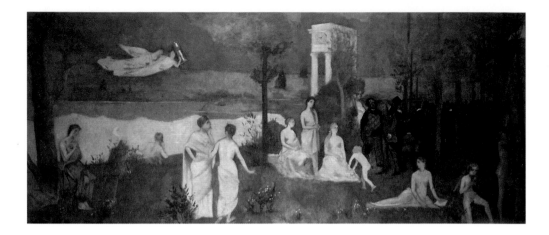

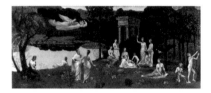

PARODIE DU 'BOIS SACRÉ' DE PUVIS DE
CHAVANNES, 1884
(Parody of Puvis de Chavannes'
The Sacred Grove)
oil on canvas, 67 3/4 × 149 5/8 in.
(172 × 380 cm)
The Henry and Rose Pearlman Foundation,
Inc.; Dortu P. 232

Puvis de Chavannes
LE BOIS SACRÉ CHER AUX ARTS ET MUSES,
c. 1884–89
(The Sacred Grove Cherished
by the Arts and Muses)
oil on canvas, 36 1/2 × 91 in. (92.7 × 231 cm)
The Art Institute of Chicago,
Mr. and Mrs. Potter Palmer Collection

are what transform it from a copy or variation into a joking commentary. Where Puvis' image offers an idyllic allegory of the arts in timeless classical setting and costume, with muses near a triumphal arch in the center of a peaceful wood, the Cormon students added an intruding group of modern visitors and sightseers. Prominent among them are the student-artists themselves, with Toulouse-Lautrec near the front, seen from the back, his legs spread in the unsteady walk he compared to that of a duck.[10] This intrusion of the contemporary, as well as other altered elements, into Puvis' composition clearly disrupts its ideal, atemporal unity conceptually, iconographically, and stylistically, but underlying it is also the sense of cohesion and community shared by the young artists, predominantly of bourgeois origin, and the leading presence Toulouse-Lautrec had among them. Here, unlike among members of his own family and class, he was accepted, honored, and thought of as an equal.

I want to emphasize another aspect of the parody of Puvis' programmatic painting. The artists and others who crowd into the painting as alien presences destroy the timelessness of the scene, as I have already stated, and this focus on the here and now contrasts significantly with Puvis' own world of a personalized classicism. Reality intrudes into the idyllic, and realism intrudes into idealism. The emphasis on representing what is seen and experienced rather than a realm of abstractions and allegories corresponds to the content and mode of the paintings

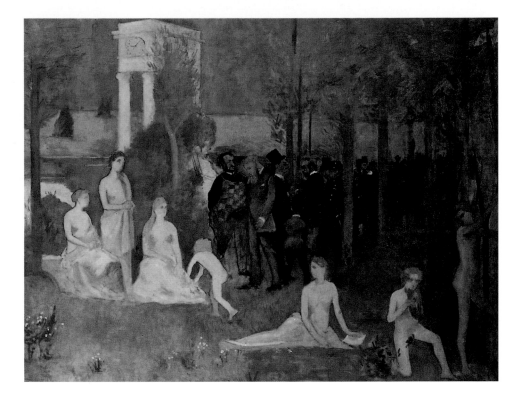

Toulouse-Lautrec and other Cormon students were producing outside the studio. Similarly, the substitution of a tube of oil paint for the allegorical lyre carried by one of the flying muses insists on the material reality that comprises a painting and that separates it from the other arts, rather than accepting Puvis' idealist equation of all arts and the particular correspondence between painting and music. The brazen entry of the artists and others into the "sacred wood" thereby becomes a statement of artistic ideology which demands recognition of material reality and a bold adherence to observation and the contemporary.

For Toulouse-Lautrec at this time, the "realism" announced in the parodic painting seems to have consisted of a combined emphasis on the material reality composing his image — the substance of paint and its support — and on a portraitlike individuality and recognizability for his figures, whether or not they were strictly portraits. The painting now entitled *La grosse Maria, Vénus*

PARODIE DU 'BOIS SACRÉ' DE PUVIS
DE CHAVANNES, detail

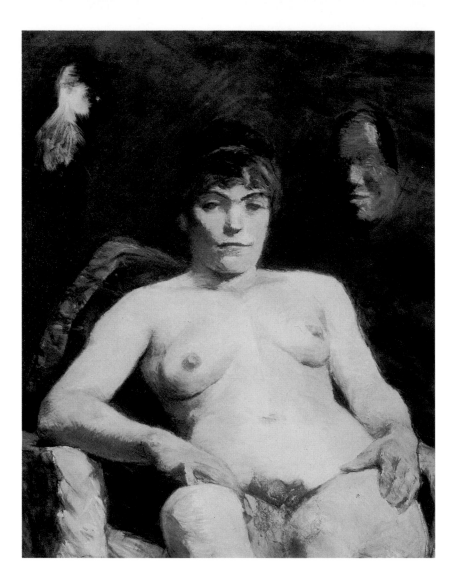

La grosse Maria, Vénus de Montmartre,
c. 1885
(Voluptuous Mary, Venus of Montmartre)
oil on canvas, 31 3/4 × 25 1/2 in.
(80.7 × 64.8 cm)
Von der Heydt Museum, Wuppertal;
Dortu P. 229

de Montmartre — who provided this identification and when is not clear, but it is unlikely that it was Toulouse-Lautrec — thus offers a definite portrait likeness of the model as she gazes directly out of the canvas, her face depicted frontally so as to make her individual features immediately discernable. Moreover, the portrait effort is continued in the representation of the model's naked body. Indeed, the effort at individuation may have led to the disjunctive structure of the figure, which is rendered from three distinct positions — with eye levels at the

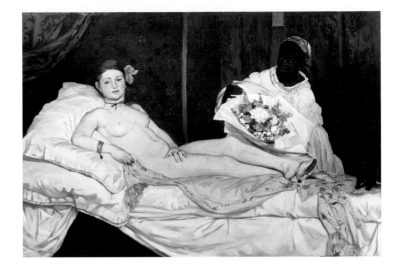

knees, the breasts, and the head — as if Toulouse-Lautrec, while remaining directly in front of her, shifted his eyes in relation to her body in order to render each portion of her from the most revelatory or characterizing viewpoint, thereby avoiding foreshortening or other distorting devices except in the arms and legs. Introduced into the facture of the painting are regularly divided brush strokes that mold themselves to shape contours and volumes as well as to break up tones. With its brown background on which appears a mask and an imprecisely rendered male head, the painting follows the practices of studio nudes as rendered in Cormon's atelier. The undisguised contemporary nakedness of the model and her direct gaze, however, also reveal Toulouse-Lautrec's effort to emulate Realist practices and, indirectly perhaps, the prototype of Edouard Manet's *Olympia* with its representation of a Parisian prostitute with a similarly steady outward gaze. Apparently painted late in 1885 or 1886, *La grosse Maria* is one of Toulouse-Lautrec's earliest attempts at an incontrovertibly modern painting. It combines sexually charged contemporary subject matter — a woman whose direct confrontation and unabashed nakedness serve as iconographic signs of her identity as a prostitute — with accented, divided brush strokes and green-tinged shadows derived from a modified Impressionism and imposed over the grayish silver tonality of his earlier paintings.

Edouard Manet
OLYMPIA, 1863
oil on canvas, 51 3/8 × 74 3/4 in.
(130.5 × 190 cm)
Musée d'Orsay, Paris

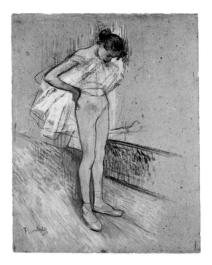

"*Vive la Revolution! Vive Manet!*" Toulouse-Lautrec wrote with exaggerated, ironic enthusiasm to his mother. "An impressionist wind is blowing through the studio. I am delighted ..."[11] With other young students at Cormon's studio — particularly open to experiment were Louis Anquetin, Emile Bernard, and Vincent van Gogh — he turned increasingly away from traditional and moderately modern modes of work and looked more at the radicality of Impressionism and Neo-Impressionism to develop his own individual techniques. Larger than any other prior independent painting by him, even as it offered a variation on traditional Academic motifs and practice, *La grosse Maria* was an audacious, ambitious, but unfinished effort to approach these new "revolutionary" artistic standards, which also marked a further departure from the aristocratic conservatism of father and family.

Apparently addressing questions she had after hearing about his mode of life and his new work from his father, he admitted to his grandmother,

> I'm not actually regenerating French art at all, and I'm struggling with a poor piece of paper that hasn't done anything to me and on which, believe me, I'm not doing anything good. I would like to talk to you a little about what I am doing, but it is so special, so much 'beyond the rules.' Papa would consider me an outsider, of course.[12]

Self-deprecating humor and the contention that his art was incomprehensible to his family, especially his father, replaced any effort at explanation even as he attempted to justify himself. Ambivalence marked his attitudes toward his situation, however, and an undertone of regret cannot be denied. The art that distanced him from the mores of his class, moreover, he now put forward as the cause of further necessary changes in his way of life:

> I'm going against my own taste [as] I openly live the life of a bohemian and I'm hardly used to these surroundings. I am all the less at ease on the butte Montmartre because I feel myself held back by a mess of sentimental considerations that I'm going to have to forget altogether if I want to get anywhere.[13]

Danseuse ajustant son maillot ou Le premier maillot, 1890
(Dancer Adjusting her Costume or The First Costume)
black chalk and oil on cardboard,
23 $^1/_4$ × 18 $^1/_8$ in. (59 × 46 cm)
Private collection, Switzerland; Dortu P. 371

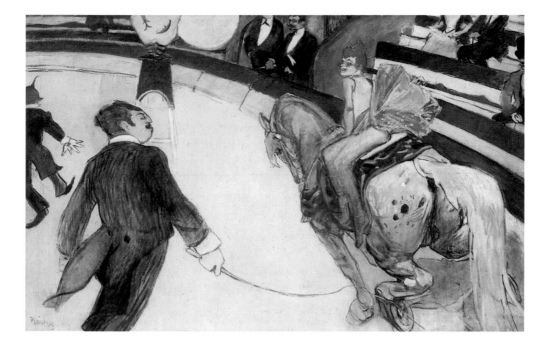

Au Cirque Fernando, l'Écuyère, 1887–88
(Acrobatic Rider at the Cirque Fernando)
oil on canvas, 40 5/8 × 63 1/2 in.
(103.2 × 161.3 cm)
The Art Institute of Chicago, The Joseph
Winterbotham Collection, Dortu P. 312

When he wrote this at the end of 1886, whatever the "sentimental considerations" may have been had largely been overcome, however, and he was a regular participant in the butte's varied activities. Cormon's atelier lost significance as he now had his own studio and apartment — the site of his "life of a bohemian" — at the intersection of the rue Caulaincourt and the rue Tourlaque on Montmartre. It was possibly there that he painted "la grosse Maria," although she may well have been one of Cormon's models, too, and there that he began to seek out motifs for his drawings and other paintings almost exclusively in the streets, music halls, and cabarets. He continued to paint portraits of his friends — the young male artists and their female companions who likewise lived in Montmartre — but his prior interest in farm laborers, Academy nudes, and mythology gave way to the laundresses, prostitutes, singers, circus entertainers, and dancers, along with their bourgeois and aristocratic admirers and patrons, for which he is known today.

It was a sudden conversion. One motivation may have been the simple one of matching the world of his art to the world he experienced around him in accordance

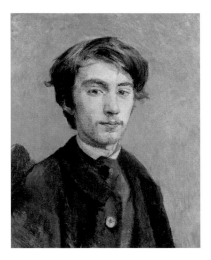

with Realist and Naturalist principles, but the issue of his professionalism as an artist also must have been a major contributing factor. By the mid-1880s, representations of the urban *vie moderne* which concentrated on the lower classes, male and female laborers, café and music hall life, bar scenes, and prostitutes were relatively commonplace in non-Academic art. Jean-Louis Forain and Jean-François Raffaëlli were probably its most successful proponents, working in a Naturalist-Realist mode that borrowed heavily from the innovations of Manet, Degas, and the Impressionists, but that gave their radicality an overlay of clear narrative, sentimentality, humor, and picturesqueness which appealed to a more broadly defined public otherwise alienated by the avant-garde. Moreover, popular illustrated periodicals such as *Le Courrier français* or *Paris illustré* provided ready markets for reproductions of paintings and drawings focused precisely on such motifs. It was this market that Toulouse-Lautrec's altered motifs and technique addressed in 1886, and it was as illustrator for these periodicals more than as painter that he initially attempted to establish a professional identity. "I still haven't appeared in the papers but now it's going to happen. Finally!! My drawing for the *Courrier français* remains in an embryonic state, but I'm going to get it done," he wrote to his mother.[14] Commercial viability and the sale of his work, not elevated principles of the fine arts, fueled his ambition.

The "descent" into illustration and commercial art, combined with his explorations of bohemian Montmartre, again aggravated relations with his family, and it is likely the issue his grandmother queried. His father offered to rent a studio for him in a more fashionable section of Paris near the Arc de Triomphe, away from Montmartre and its influences. Toulouse-Lautrec resisted vehemently, arguing it would be a salon suitable for five o'clock teas, not the environment he needed to inspire salable illustrations such as the drawing *Gin-Cocktail* finally published in *Le Courrier français* in September. He attempted to assure his mother too that he was not living a life of debauchery and drink after telling her he had been at the Cabaret du Chat Noir until five o'clock in the morning: "My life really is quite dull and I assure you that

EMILE BERNARD, 1886
oil on canvas, 21 ¹/₂ × 17 ¹/₈ in.
(54.5 × 43.5 cm)
The Trustees of the Tate Gallery, London;
Dortu P. 258

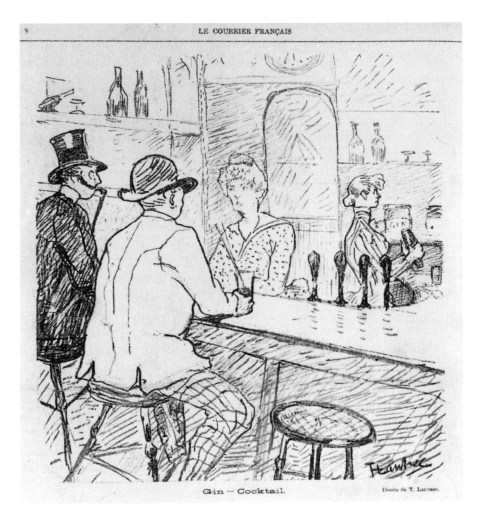

Gin -- Cocktail. Dessin de T. Lautrec.

GIN-COCKTAIL

illustration in *Le Courrier français*,

26 September 1886

8 5/8 × 7 7/8 in. (22 × 20 cm)

Herbert D. Schimmel, New York

evenings *sur le pavé* are not always marked by wild gaiety."
And similarly, after his father held back rent money, he
emphasized in capital letters, "I SHALL WORK HARD AND
TRY NOT TO DRINK."[15] The work he produced, however,
maintained its new focus precisely on the *vie sur le pavé*
and documented Toulouse-Lautrec's allegiance to values
preached not by his aristocratic father, but by the newly be-
friended Aristide Bruant, owner of the cabaret Le Mirli-
ton. In Bruant's songs as in Toulouse-Lautrec's new
works, the poor, criminals, prostitutes, and other social
outcasts were featured, not the aristocracy and its "life in
the out of doors." Montmartre's bohemia appeared tri-
umphant over the genealogy of Toulouse-Lautrec Montfa.

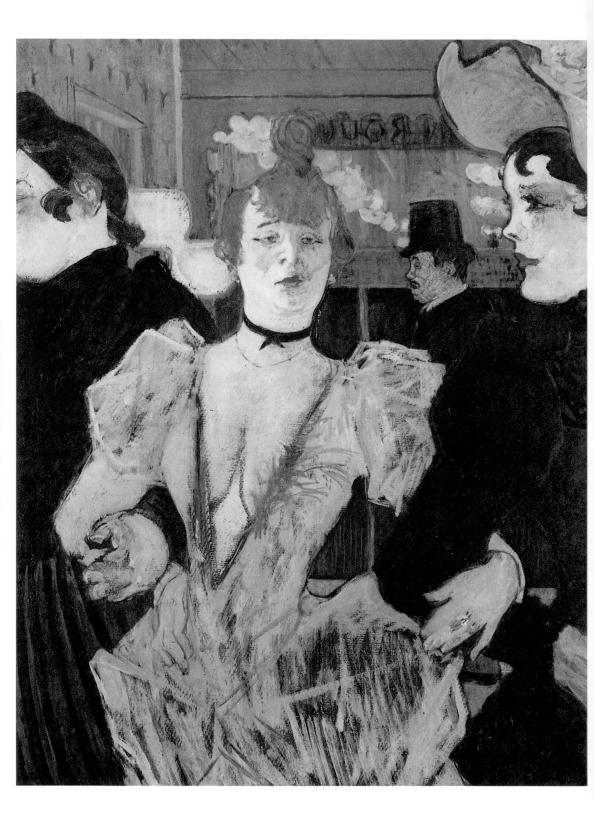

La Vie bohème: Eroticism, Decadence, and Anarchism

Au Moulin Rouge offers us a look into the famed Montmartre dance hall of the 1890s and at several groups of its customers. Seated around a foreground table are two of its women entertainers in the company of three male admirers. All were friends of Toulouse-Lautrec, who depicted himself walking through the central background of the scene at the side of his cousin, Gabriel Tapié de Céleyran. At the table, from left to right, are the poet Edouard Dujardin, the dancer La Macarona, the photographer Paul Sescau, the vintner Maurice Guibert, and the red-haired dancer Jane Avril. Behind them, two other performers — the dancers La Goulue and La Môme Fromage — stand together. And at the far right edge of the painting, the face and figure of another dancer, May Milton, appear.[16]

The setting is a raised, partially glazed alcove for tables and a promenade adjoining the main dance floor, separated from it by a low railing. In other works by Toulouse-Lautrec, these alcoves often serve as backgrounds to scenes taking place on the dance floor, and they are apparent also in contemporary photographs of the dance hall. However, in no other work is the alcove itself, where observers sit and eat or else walk past, his focus. Here in *Au Moulin Rouge*, it is we, the viewers of the painting, who are projected into a position immediately outside the alcove, hypothetically on the dance floor itself, as we look onto the group around the table and are confronted by May Milton, her face sharply illuminated by an unseen cluster of globed lights on the pillars separating the alcoves. The entire painting, in terms of its perspectival organization, is oriented around this blond woman and her garishly lit face. As she leans toward us, we focus on her lips before recognizing the remainder of her face around them. Only then do we gaze over into the alcove itself. This situation, as I have described it, corresponds precisely to that of someone Toulouse-Lautrec's height were he standing on one of the benches lining the dance floor beneath the alcove railings. Through his staging of his painting, he has forced us, the viewers, to adopt his unique child-high perspective as our own.

La Goulue entrant au Moulin-Rouge,
1891–92
(La Goulue entering the Moulin-Rouge)
oil on cardboard,
31 1/4 × 23 1/4 in. (79.4 × 59 cm)
The Museum of Modern Art, New York,
Bequest of Mrs. David M. Lévy; Dortu P. 423

Au Moulin de la Galette, La Goulue et
Valentin le Désossé, c. 1893-94
(At the Moulin de la Galette, La Goulue and
Valentin, the 'Boneless One')
oil on cardboard,
20 $^1/_2$ × 15 $^3/_8$ in. (52 × 39.2 cm)
Musée Toulouse-Lautrec, Albi; Dortu P. 282

La Goulue, 1894
lithograph, 12 $^3/_8$ × 10 $^1/_8$ in. (31.4 × 25.7 cm)
The Museum of Modern Art, New York,
Bequest of Abby Aldrich Rockefeller; Delteil 71 I

A tactic of compositional organization learned
from varied sources, Edgar Degas and Japanese prints
above all, and shared in Paris with many of the younger
progressive artists of the 1890s, overt emphasis on a parti-
cular viewpoint and visual angle often appears in Toulouse-
Lautrec's work and indeed is one of its defining character-
istics. If we examine his paintings of the early 1890s in
terms of their viewpoints, we see that they frequently po-
sition our eyes at the level of figures' shoulders, chests, or
even lower, much as the artist himself would have ex-
perienced them when looking up from his stunted height
(see pp. 24, 28). Following traditions of European paint-
ing, the device of placing the viewer in a lower, inferior
position in relation to the figure depicted has been em-
ployed to monumentalize and idealize. In portraits of
kings and other rulers, for example, we consistently are
made to gaze up as they appear to loom over us in size and
position to signal their superiority, authority, and domi-
nance. Toulouse-Lautrec, however, employed this device
as part of a vocabulary of presence which accents the
eccentricity of his individual viewpoint and its apparent-
ly accidental aspects, not only in terms of height but also
when figures or objects are pushed to the extreme edges
of a painting, there often to be cut off haphazardly (see
p. 24). Such radical cropping and eccentricity of viewpoint
— the snapshot quality of Toulouse-Lautrec's images —
offer a sense of the immediate and momentary which the
Impressionists and Degas had already exploited. As a
particular hallmark of artistic contemporaneity, they were
used by Toulouse-Lautrec to accent his own and his
viewer-surrogate's physical position as witness, thereby
offering testimony to the reality or veracity of the scene
depicted as something personally experienced. Although
he painted few self-portraits, Toulouse-Lautrec incor-
porated himself into all his mature paintings by means of
his accented construction of physical witness. The physio-
logical limitations of his crippled body comprised the
principle around which his painted world was organized.
We as viewers are placed within this world through the
logic of pictorial organization.

It was as a witness narrating an account of activ-
ities in Montmartre dance halls and bars that Toulouse-

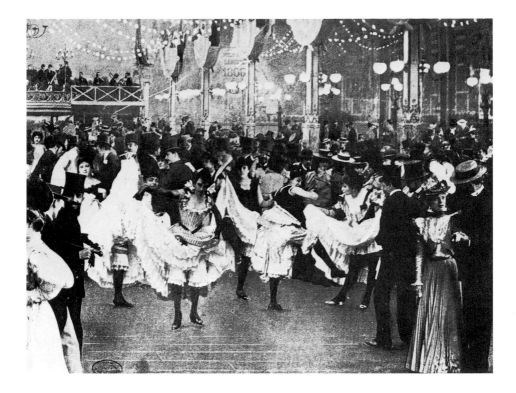

View of the dance hall of the Moulin-Rouge, photograph *c.* 1895

Lautrec first presented his work to the Parisian public in illustrations published by *Le Courrier français* in September 1886, and in December in *Le Mirliton*, the house periodical of Aristide Bruant's Montmartre cabaret. As he failed to place paintings in the Paris Salons, such illustrations offered an alternative pronouncement of professional maturity. Work as an illustrator guaranteed broad public exposure as a clear index of professional recognition and through the subject matter of Montmartre night life linked him to a small group of other Montmartre artists, most notably Raffaëlli and Adolphe Willette. The illustrations, moreover, identified their art as overtly commercial activity, money being exchanged for products of artistic labor, and thus provided him with one of the key characteristics of a lower bourgeois, artisan, or even laboring-class existence. His way of life and his art combined again to suggest rejection of the ideals and aims of the moneyed classes or a deliberately provocative flaunting of values antithetical to them. In effect, Henri de Toulouse-Lautrec proletarianized himself through his work.

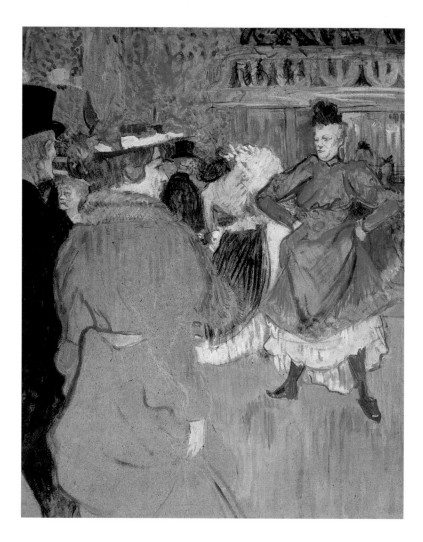

AU MOULIN-ROUGE, LE DEPART DU
QUADRILLE, 1891–92
(In the Moulin-Rouge:
The Beginning of the Quadrille)
oil and gouache on cardboard,
31 ¹/₂ × 25 ⁵/₈ in. (80 × 65 cm)
National Gallery of Art, Washington,
D.C., Chester Dale Collection; Dortu P. 424

As the cover of *Le Mirliton*'s last 1886 issue, the grisaille painting *Le Quadrille de la chaise Louis XIII à l'Elysée Montmartre* marked a year's end and another year's beginning. Commissioned by Bruant, it centers on a trio of dancers — La Goulue, Grille d'Egout, and Valentin le Désossé — with Bruant in his broad-brimmed hat as overseeing fourth partner. The setting is one of Montmartre's oldest large dance halls, founded in 1840, under new management since 1881, and located on the boulevard Rochechouart next door to the cabaret Le Mirliton. Although the class identity of the dance hall public was fluid, during 1886 the lower classes dominated L'Elysée Mont-

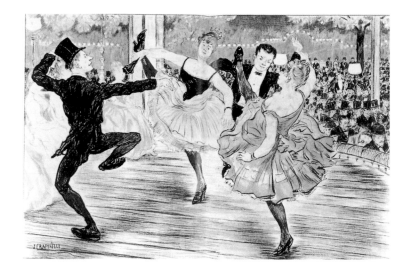

martre's clientele; they were joined, however, by artists whose studios were nearby such as Louis Anquetin and François Gauzi, seen as they enter at the right edge of the illustration, or Toulouse-Lautrec himself, the implied witness to the scene.

During the evenings, public dancing was interrupted periodically, space was cleared, and four semi-professional dancers performed a popular dance, the *chahut* variation known as the *quadrille naturaliste*. In *Paris illustré*, the poet-critic Maurice Vaucaire described the finale of the dance as a

> wondrously insolent *blague* in which two women turn
> to face each other by dancing rapidly on the left foot
> while the right one remains raised to eye level. They
> were sheathed in silk stockings and lace-filled batiste
> pantaloons, all within a froufrou of pretty petticoats
> thrilling to see whether you are naive or blasé.

Jean-François Raffaëlli
LE QUADRILLE NATURALISTE AUX
AMBASSADEURS
(The Naturalist Quadrille at the
Ambassadeurs Dance Hall)
drawing reproduction for *Paris illustré*,
August 1886
Biblothèque Nationale, Paris

A danced *blague*, a disrespectfully insolent, impious, coarse joke of erotic suggestion, the *chahut naturaliste* was associated with the masses, their values and their volatile, potentially revolutionary political identity within the Third Republic, then under severe attack from both right and left:

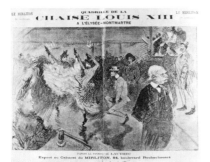

The women's names did not fail to project something of the crowd's poetry: La Goulue [The Glutton] and Grille d'Egout [Sewer Grating]! The one skinny and nervous, laughing delicately and mysteriously; the other hefty, her face immobile, proud of her mission in life: to stuff it in.

From their suggestive pirouetted display of lace and linen underwear, the two women project an unrefined plebian character that signals a natural, instinctive enjoyment of life, but also explosive unpredictability and mystery to the bourgeois poet:

> The men who served as these girls' partners, dressed in provincial calico, pirouetted with them and lifted them high as if to tell the public: These are our women, they are of the people, we are their true companions, they'll always come back to us." And the men dedicated to them that exaggerated choreography, those suggestive gestures, this sign language worthy of the argot.[17]

LE QUADRILLE DE LA CHAISE LOUIS XIII À L'E-
LYSÉE MONTMARTRE, 1886
(The Louis XIII Chair Quadrille at the Elysée
Montmartre [Montmartre Elysium]
Dance Hall)
painting reproduced in *Le Mirliton*,
29 December 1886
Private collection; Dortu P. 261

LE REFRAIN DE LA CHAISE LOUIS XIII AU
CABARET D'ARISTIDE BRUANT, 1886
(The Refrain of the Louis XIII Chair Quadrille
at Aristide Bruant's Cabaret)
oil on paper on canvas,
30 7/8 × 20 1/2 in. (78.5 × 52 cm)
Private collection, Paris; Dortu P. 260

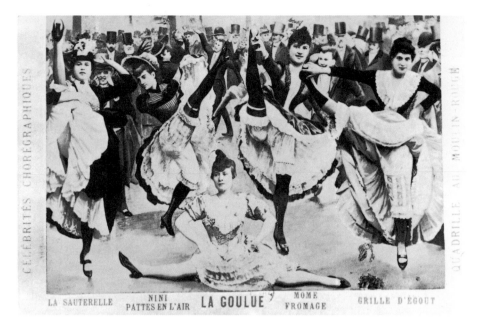

The dancers of the Moulin-Rouge
with La Goulue in the center

Illustrated with drawings by Raffaëlli, Vaucaire's article characterizes the dancers as provincial and lower-class, vulgar and natural, undisciplined and sincere in their lack of refinement. Similarly perceived was the *quadrille naturaliste* itself as they danced with accented, frenetic movement, ribald gestures, and lascivious display to the excitedly rhythmic brass music of the *chahut* or cancan. Impious, disrespectful, humorous, confrontational, discordant, and sensual, the *quadrille naturaliste* was a visualized argot, the slang spoken by workers, tradesmen, and petty criminals. Like the argot, it was consciously positioned outside the confines of respect and social authority, a persistent critique and threat to them.

Despite this identity of the dance with non-bourgeois and anti-authoritarian attitudes and classes, it was precisely to the prosperous segments of Paris that Vaucaire's article, Raffaëlli's illustrations, and also Toulouse-Lautrec's painting were addressed. They offered safely distanced but intimate views into a milieu of the *bas peuple* deemed alien and dangerous but simultaneously picturesque and engaging. If initially, the dance halls of Montmartre with their loud music and commercial sensuality, their gas lights and fumes, their smells of sweat, exhaled breath, cigarette

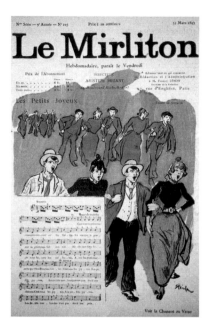

THÉOPHILE STEINLEN

Illustration to "Les petits joyeux" published

in *Le Mirliton*, No. 203

(31 March 1893)

smoke, and beer were a means of escape from the cares of the everyday for their proletarian and artisan clientele, by the mid-1880s they were also attracting other social classes. Replete with auras of the vulgar, the dangerous, and the forbidden, the dance halls were invaded with fascination, compassion, and bemusement first by journalists, novelists, and artists, then by the bourgeois and upper-class publics their writings and pictures addressed.

Toulouse-Lautrec's cover painting for *Le Mirliton* therefore existed as a medium of advertisement, a published site of social intersection. For his social peers, it previewed the venue of their social tourism, showing what he witnessed and what they wished to see: a prostitute alone in the shadows with a glass of beer; a silhouetted collective frieze of onlookers and the orchestra above them; women dancers with legs raised high in the *port d'arme* position amid the rustling explosions of white petticoats; Valentin le Désossé, the "Boneless One," crouched before them as Aristide Bruant stands nearby; and an aging "inspector of decency" turning away conspicuously from the potentially offending performance as Anquetin and Gauzi enter nearby. Toulouse-Lautrec and Bruant offered *Le Mirliton*'s bourgeois readers a preview inventory of the dance hall's varied entertainment and services — drinking and dancing, raucous music, sex for sale — available in a setting of anonymity and overt official acquiescence.

When Bruant selected the painting for the cover of the new year's issue of *Le Mirliton*, the *quadrille naturaliste* depicted also was offered as a natural, "naturalist" antithesis to the artifice, pomp, and masquerade of Parisian new years' balls and celebrations. Implicit in the image's publication was a reproach of French bourgeois and upper-class society, its practices and its values. "And it was not only artists, men of letters, poets, Montmartrois bohemians who came eagerly [to the cabaret]; it was men of the world, grand dukes 'doing' the capital, elegant and décolletéed women exploring the Butte, snobs, rich bourgeois driven in landaus to the boulevard Rochechouart," recalled Alexandre Zévaès, Bruant's socialist biographer. At the cabaret, they were welcomed with "the most audacious and the most offensive rudeness," by "invectives

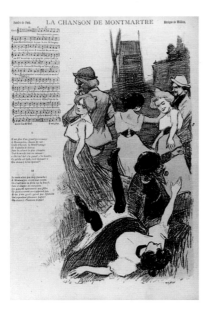

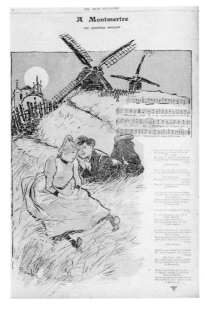

P. Ballariau
"Chanson de Montmartre" for *Gil Blas*,
No. 17 (29 April 1898)

Théophile Steinlen
Illustration to Bruant's chanson
"A Montmartre" for *Gil Blas*, No. 34
(21 August 1892)

and caustic insults" addressed to them in a modified argot by Bruant "every day, from ten in the evening until two in the morning, [as] he sings his faubourgien couplets, sometimes walking up and down among the packed-in customers, sometimes perched on a table."[18] The performances reversed social positions as the bourgeois audience was made aware of its otherness, was situated outside the milieu into which it voluntarily placed itself, and participated in the celebration of an alternate reality disruptive of its own bourgeois standards and institutions.

Published in each issue of *Le Mirliton*, Bruant's songs projected a sympathetic, frequently sentimental, sometimes bitter, melancholy, and compassionate voice for the poor and disenchanted, the homeless and beggars, street toughs and seamstresses, petty criminals and pimps, streetwalkers and rag collectors of Montmartre and other proletarian and sub-proletarian faubourgs. Using argot, Bruant identified these individuals collectively as the *dos*, as male *marlous* and female *marmites*:

> *A bas la romance et l'idylle,*
> *Les oiseaux, la foret, le buisson,*
> *Des marlous de la grande ville,*
> *Nous allons chanter la chanson:*
> *V'là les Dos, vivn't les Dos!*
> *C'est les Dos les gros,*
> *Les beaux,*
> *A nous les marmites!*
> *Grandes ou petites;*
> *V'là les Dos, vivn't les Dos!*
> *C'est les Dos les gros,*
> *Les beaux,*
> *A nous les marmit's et vivent les Dos!*[19]

> *Down with romance and idylls,*
> *with birds and forests and bushes.*
> *We, the* marlous *of the city,*
> *will sing this song:*
> *Here are the* dos!
> *Long live the* dos!
> *We're the* dos,
> *the grand, the handsome.*
> *Big or small,*
> *the* marmites *are our own.*
> *Here are the* dos! *Long live the* dos!
> *We're the* dos, *the grand, the handsome.*
> *The* marmites *are our own and long live the* dos!

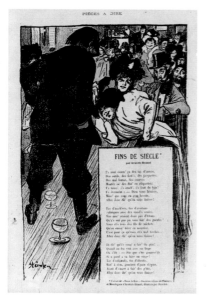

Existing on the margins of Parisian society, its fitfully-employed flotsam and its street people clothed in workers' blue smocks, this underclass complained with ironic humor through Bruant's chansons of its fate, sang of its romances, celebrated the ordinary events of its lives, and cursed and threatened its social antagonists: the aristocracy, the bourgeoisie, priests, police, and landlords: "J' tap'rai dans l' tas d' ceux qu'a pas d' blouse" (I'll punch in the nose all those not wearing our smock).[20] Repeatedly, Bruant's songs, collected in 1889 into two volumes under the title *Dans la rue* (In the Street), speak the erotic laments and reminiscences of the *marmites*, the women of the demimonde:

> *Quand j'vois des fill's de dix-sept ans,*
> *Ça m'fait penser qu'ya ben longtemps,*
> *Moi aussi j' l'ai été pucelle*
> *A Grenelle.*
>
> *Mais c'est eun quartier plein d'soldat*
> *On en rencontre à tous les pas,*
> *Jour et unit i's font sentinnelle*
> *A Grenelle.*
>
> *J'en ai t'i connu des lanciers,*
> *Des dragons et des cuirassiers,*
> *I's m'montraient à m' teniren selle*
> *A Grenelle.*
>
> *Fantassins, officiers, colons*
> *Montaient à l'assaut d' mes mam'lons,*
> *I's m' prenaient pour eun citadelle,*
> *A Grenelle.*
>
> *Moi j'les prenais thus pour amants,*
> *J'commandais thus les régiments,*
> *On m'appl'lait mam' la colonelle,*
> *A Grenelle.*
>
> *Mais ça m'rapportait que d' l'honneur,*
> *Car si l'amour ça fait l'bonheur,*
> *On fait pas fortune avec elle,*
> *A Grenelle.*
>
> *Bientôt j' m'aperçus qu'mes beaux yeux*
> *Sonnaient l'extinction des feux,*
> *On s'mirait pus dans ma prunelle,*
> *A Grenelle*
>
> *Mes bras, mes jambes, mes appas,*
> *Tout ça foutait l'camp, àgrands pas,*
> *J'osais pus fair' la p'tit' chapelle,*
> *A Grenelle.*

Théophile Steinlen
Illustration to Bruant's chanson "La vigne au vin" and "Fins de siècle" for *Gil Blas*, No. 21 (12 June 1892) and No. 8 (24 February 1895)

Théophile Steinlen
Illustration to "Le Moulin de la Galette" by
André Gill, published in *Gil Blas*, No. 38
(18 September 1892)

Aujourd'hui qu' j'ai pus d' position,
Les Régiments m' font eun' pension:
On m' laiss' manger à la gamelle,
A Grenelle.

Ça prouv' que quand on est putain,
Faut s'établir Chaussé'-d'Antin,
Au lieu d' se faire eun clientèle,
A Grenelle.

Whenever I see girls seventeen years old,
I'm reminded that long ago
I too was a young maiden
In Grenelle.

But it's a quarter with lots of soldiers.
You meet them wherever you turn,
Day and night they're out on watch
In Grenelle.

And so I got to know lancers,
Dragoons, and cuirassiers,
Who showed me how to hold my position
In Grenelle.

Infantry, officers, colonels
Mounted attacks on my two mounds,
They thought I was a citadel,
In Grenelle.

Me, I took them all on as lovers,
I commanded all the regiments,
And they called me their Miss Colonel,
In Grenelle.

But it yielded me nothing, only honors,
Because if love makes you happy,
You don't make a penny,
In Grenelle.

Soon I noticed that my beautiful eyes
Now sounded taps,
And nobody gazed into their depths
In Grenelle.

My arms, my legs, my tits,
All broke up camp in double time.
I don't even dare call the roll
In Grenelle.

Now I've got no position,
The regiments gave me a pension:
They let me eat after the raw troops
In Grenelle.

This all proves that if you're goin' t' be a whore,
Set up your quarters at the Chaussé'-d'Antin
And don't seek your clientele
In Grenelle.

The voice speaking in Bruant's chanson, published in *Le Mirliton* on 15 May 1886, is clearly male, even if its fiction identifies it as that of the prostitute herself, speaking her argot in the Grenelle section of Paris, near the Ecole Militaire. Sexual innuendo and *double entendres* join with a sentimentalized history of her life as a search for love or an innocent submission to its attractions as she "serves" in the regiments. The realities and frequent abuse experienced by prostitutes have no place here, although a sense of compassion is apparent, since any woman who ceases to be attractive to the soldiers is thereby deprived of her profession and is forced to accept food offered in charity at the recruits' mess.

Virtually an illustration of Bruant's song is a large, incomplete colored sketch on tracing paper that Toulouse-Lautrec made in 1886 of a café interior where a soldier in the uniform of an artilleryman stands, grins, and stares at a woman seated in the foreground. The sketch is the last of a series of six devoted to the motif or aspects of it, traced and reworked repeatedly until the final version in which color was applied to the forms. The process was one learned in Cormon's studio; the repetition and reworking are indicative of the importance the image seems to have had for Toulouse-Lautrec as he attempted to derive a first independent composition from the demimonde milieu Bruant celebrated. With its broadly brushed forms and dashes of bright coloration, the sketch is often thought to foreshadow later painting practices, but this is less an isolated prediction of what would come than a sign of dissatisfaction and failure. As originally conceived, the figure of the soldier — for which the artist Frédéric Wentz posed — looked down at the seated women, who is seen in profile and who appears alone in several of the preparatory sketches. The composition thus was collaged from two independently conceived figures, and the scene of erotic interplay, of the soldier seeking to attract the prostitute's attention as he grasps his trousers, did not find a solution in the various studies as the components remained disjointedly separate. With the final sketch, Toulouse-Lautrec completed the soldier's figure, but then aggressively caricatured the prostitute in an anatomically impossible pose, made her turn her face toward the viewer, slashed

ARTILLEUR ET FEMME, 1886

(Artilleryman and Woman)

oil on tracing paper

22 ¹/₂ × 18 ¹/₈ in. (57 × 46 cm)

Musée Toulouse-Lautrec, Albi; Dortu P. 272

A Grenelle ou La Buveuse d'absinthe,
1886
(At Grenelle or The Absinthe Drinker)
oil on canvas, 21 5/8 × 18 in. (55 × 45.8 cm)
Joseph Hazen Collection, New York;
Dortu P. 308

red into the area of the lips, and coarsely sketched in her breasts with equally red nipples. That done, he abandoned the project.

Artilleryman and Woman, had it been completed, would have been a precise analogue to Bruant's song "A Grenelle." Another painting, however, actually bears the song's title. One of at least five Toulouse-Lautrec paintings Bruant owned and exhibited at his cabaret beginning in December 1886, it shows the same woman, alone now, seated at a table with a glass of absinthe before her. Since an initial drawing of her at the table, in the pose she assumed in the painting and the artilleryman sketches, was inscribed *1886 à Grenelle*[,] *Mirliton*, the association of picture, song, and Bruant was made by Toulouse-Lautrec

himself, a sign of his ambition to link his work with the controversial cabaret and its owner.

A Grenelle fails significantly to function as a simple illustration to aspects of the chansons, however, and appears independent even as it proclaims its linkage. Instead of showing a scene from the song's narrative, the painting continues a tradition of depicting urban types, archetypical representations of individuals whose appearance and demeanor are meant to convey the identifying characteristics and signs of class, profession, or ethnic group. It offers a profile portrait study of a coarse-featured, dark-haired, corsetted proletarian type, pensive and melancholy as she sits at a café table, a glass before her. A dim light illuminates her face, bodice, and arms as well as the glass, but the remainder of the scene is indicated only in shadow, in a dark tonality of turpentine-thinned paint — a technique favored by Raffaëlli — applied in broadly patterned brush strokes. The motif and painting manner continue the Naturalist genre of café scenes and portrait types successfully practiced by Manet, Degas, Raffaëlli, and Forain, with only the title separating it from them, linking it instead to the contemporary *"dans la rue"* poetry of Bruant. In effect, through Bruant Toulouse-Lautrec updated the others' work, enabling him as he sought to establish his own artistic presence to profit simultaneously from their successful precedent and from the controversial currency of Bruant and the Montmartre milieu.

With the exception of *Le Quadrille de la chaise Louis XIII*, the Toulouse-Lautrec paintings hung by Bruant in his cabaret in December 1886 consisted of similar portraitlike, genre-related representations of proletarian women associated through the titles with the chansons about various proletarian sections of Paris. *A Montrouge*, painted in late 1886, for example, has little in common with Bruant's song other than the woman's accentuated red hair. Bruant speaks in the voice of a Montrouge pimp who follows Rosa la Rouge as she lures a victim into a dark corner: "... and tomorrow the cop will find red, in Montrouge." Of the gruesome assault and the impudent pimp Toulouse-Lautrec's painting takes no notice; instead it silhouettes "Rosa" — the working-class model is Carmen

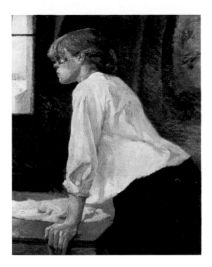

A MONTROUGE (ROSA LA ROUGE), C. 1886

(At Montrouge [Red Rosa])

oil on canvas, 28 1/2 × 19 1/4 in. (72.3 × 49 cm)

Barnes Foundation, Merion, PA; Dortu P. 305

Facing page:

LA BLANCHISSEUSE, 1889

(The Laundress)

oil on canvas, 36 5/8 × 29 1/2 in. (93 × 75 cm)

Private collection; Dortu P. 346

Gaudin, on whose bright coppery-blonde hair he focused in numerous paintings during 1884–86 — against a window, her head turned in profile, her hair disheveled, her blouse outside her skirt, sleeves rolled up. Her tousled appearance readily suggests the aftermath of sexual activity, although it is ambivalent, derived from Naturalist representations of laundresses. In these, Degas, Forain, and Raffaëlli similarly presented the women with clothes in disarray, partially unbuttoned and with arms bared to signify their physical labor and the extreme warmth of their workplaces, but also to imply sexual display or availability. The role of laundress could be associated with both sensual pleasure and social sympathy in these images, much as the women Bruant recalled in his chansons most frequently received dual accents of promiscuity and poverty. It is clearly a male, middle- or upper-class view that thus sees sexuality as an ever-present hallmark of the lower classes, a projected attack on established standards of morality and testimony to the proletariat's perceived untamed "naturalness," its willingness to accept and celebrate the instinctual, insolent, and rebellious that was also recognized in the *quadrille naturaliste*.

Toulouse-Lautrec and Bruant shared a vision of the lower classes also found in the Naturalist novels and novellas of Emile Zola, Guy de Maupassant, and the Goncourt brothers, a vision that recognized poverty's misery but that did so from a privileged position, outside the milieu itself even as it consciously took up its voice — Bruant's argot-inspired language and the insults he hurled at Le Mirliton's patrons — or bore visual witness to its accessible realities — the realms of entertainment and prostitution which intersected with those of "respectable" society — in paintings of dance halls and of the *filles du peuple*. It was through Bruant's eyes that Toulouse-Lautrec shaped his initial vision of the bohemian and lower-class worlds of Montmartre.

His imagery echoed Bruant's ideology most overtly in the drawings for *Le Mirliton*. In *Sur le Pavé* (1886), an old, top-hatted, monocled man accosts a young servant girl in a street, with a public urinal in the background. The captioned conversation makes apparent his predatory

SUR LE PAVÉ: QUEL ÂGE AS-TU, PETITE?, 1886
(On the Street: How old are you, little one?)
pencil, ink and blue chalk on cardboard,
18 3/4 × 12 1/4 in. (47.7 × 31 cm)
Sterling and Francine Clark Art Institute,
Williamstown, MA; Dortu D. 3.001

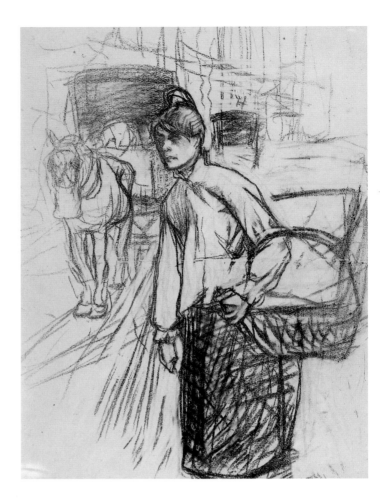

La Blanchisseuse, 1888

(The Laundress)

charcoal on paper, 25 5/8 × 19 5/8 in.

(65 × 50 cm)

Musée Toulouse-Lautrec, Albi; Dortu D. 3.028

attitude and his pedophilic predilections, but also the girl's — perhaps poverty-induced — readiness to respond to him: *Quel âge as-tu, petite? / Quinze ans, M'sieu ... / Hum! ... déjà un peu vieillotte* (How old are you, little one? / Fifteen, sir. / Hmm! ... already a bit of an old hag). Although the drawing corresponds to no Bruant chanson, it echoes the method of his condemnation of bourgeois attitudes and mores as it concentrates the imagery of working-class poverty and life into a picturesque, anecdotal situation designed to amuse and entertain as it critiques and caricatures. In paintings, in part due to their greater artistic ambition, Toulouse-Lautrec avoided such dependence and anecdotal narration after the failure to find a satisfactory solution to the soldier-prostitute situation of *A Grenelle,* but their use of Bruant's well-publicized

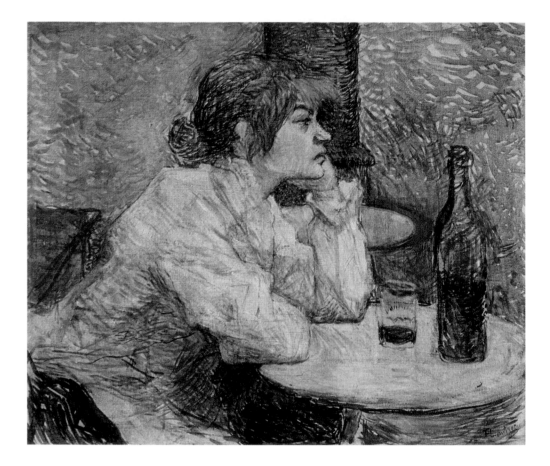

GUEULE DE BOIS OU LA BUVEUSE, 1889
(Hangover or The Drinker)
oil and black chalk on canvas,
18 $^1/_2$ × 21 $^5/_8$ in. (47 × 55 cm)
The Fogg Art Museum, Harvard University,
Cambridge, MA; Dortu P. 340

titles and their exhibition at Le Mirliton firmly cemented Toulouse-Lautrec's imagery to the cabaretist's reputation and anti-bourgeois, anti-aristocratic ideology. Alliance with Bruant formed a major tactical advance in Toulouse-Lautrec's campaign to gain an identity and reputation as a professional artist and simultaneously to affirm vigorously a reality and values antipathetic to his own class origins.

Such direct collaboration largely ceased after 1887, but Toulouse-Lautrec retained Bruant's vision with its ambivalences. *Gueule de bois* (Hangover), painted in 1889 and repeated in a drawing for *Le Courrier français*, apparently was selected by Bruant to add to the collection hung in his cabaret, if Joyant's recollection is correct. It repeats the situation of *A Grenelle*, but amplifies it in a more sophisticated and complex composition. A young woman is again seen in profile, her elbows propped on a

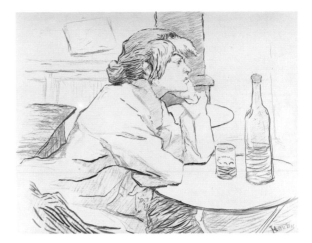

small round table on which a glass and bottle are placed, while summary indications of another table and other furnishings appear behind her. Painted with a web of interlocking, broadly tracked brush strokes in oils drastically thinned with turpentine (the technique Toulouse-Lautrec derived from Raffaëlli now systematically applied throughout), with the black pastel drawing and large areas of bare canvas remaining visible, the picture defies its illusion as it accents its material make-up, the intersection of its physical components and the process of its own production.

Technically and stylistically, *Gueule de bois* demonstrates an accented contemporaneity that pushes beyond the practices of Toulouse-Lautrec's prior Impressionist and Naturalist prototypes. It incorporates aspects of the experimentation other Parisian artists — Gauguin and his followers, Seurat and his Neo-Impressionist disciples, and Van Gogh — likewise were invoking in 1888–89 as they proposed a new anti-naturalist art. It was, now in the milieu of the pictorial arts, akin to the alliance with Bruant. Toulouse-Lautrec allied himself with a grouping of painters working outside the accepted norms and institutions, critical of them while simultaneously striving to supplant them, and in search of affiliation with the "common people." Van Gogh thus organized an exhibition of the *petit boulevard* group that included him, Emile Bernard, Louis Anquetin, and Toulouse-Lautrec — all former Cormon students — in 1887 at a Montmartre

GUEULE DE BOIS OU LA BUVEUSE, 1889
(Hangover or The Drinker)
black ink with quill and paint brush, blue
and black chalk on dark cream wove paper,
19 3/8 × 24 7/8 in. (49.3 × 63.2 cm)
Musée Toulouse-Lautrec, Albi; Dortu D. 3.091

working-class restaurant, Le Tambourin, expecting to convert a new non-bourgeois audience to their radical art statements. Artistic innovation was linked to an assumed social identity with workers, the proletariat, and the social underclass. Radicality in art formulated the subversion of established aesthetic standards and their institutions in collusion with efforts to destroy society's hegemonic order and to substitute a new utopian milieu.

Montmartre, identified since the 1830s as a site of bohemian and artistic activity and entertainment, also served as the symbolic space of political radicalism for Paris, a cultural alternative to the city's and state's social order, site of the Communards' last stand in 1871 and — as the centennial of the French Revolution was being

celebrated — stronghold of anarchist propaganda and insurgency.[21] Montmartre's association with anarchism gained great popular recognition, a circumstance exploited by Zola's 1897 novel of social unrest and political conspiracy, *Paris*, for example, in which anarchist activists reside on the butte, not in more typically working-class sections of the city. Amorphous as a political and cultural movement, encompassing varied positions from humanist egoism to communism and syndicalism, united in little but antagonism toward existing bourgeois capitalist society, especially as embodied in the Third Republic, and the search for a stateless utopian future age of individual freedom, anarchism gained its greatest visibility and popularity in France during the 1880s and '90s and found numerous supporters among the artists, writers, singers, dancers, chansonniers, and cabaretists of Montmartre. More than any other political ideology, anarchism was embraced in a bohemian culture already focused on social disenchantment, revolt, insurgence, opposition, and libertinage.

Skillfully and commandingly summarized by the anarchist terrorist Emile Henry as he addressed the jury at his trial, anarchist belief foresaw the collapse of the old order and justified bombings and other activities as the means to bring this inevitable event about:

> I was convinced that the existing social order was bad. I wanted to struggle against it so as to hasten its disappearance. I brought to the struggle a profound hatred, intensified every day by the revolting spectacle of a society in which all is base, all is cowardly, where everything is a barrier to the development of human passions, to the generous tendencies of the heart, to the free flight of thought ... You [the bourgeoisie] have hanged in Chicago, decapitated in Germany, garrotted in Jerez, shot in Barcelona, guillotined in Montbrison and Paris, but what you will never destroy is anarchism. Its roots are too deep. It is born in a society that is rotting and falling apart. It is a violent reaction against the established order. It represents all the egalitarian and libertarian aspirations that strike out against authority. It is everywhere, which makes it impossible to contain. It will end by killing you![22]

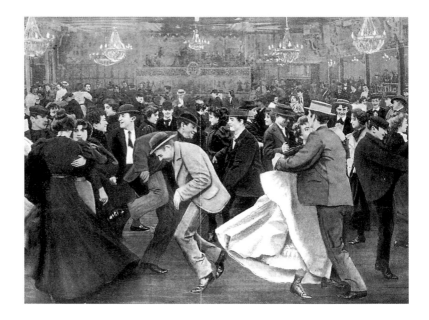

It was largely a salon anarchism that was practiced by artists and writers, however, not the "propaganda by the deed" of such militant anarchists as Henry, François-Claudius Ravachol, or Auguste Vaillant, who threw bombs into cafés and restaurants, the Paris Stock Exchange, and the Chamber of Deputies — events made notorious and legendary during the late 1880s and early '90s. But even if not practiced by them, "propaganda by the deed" received theoretical support, celebration, and aesthetic transformation in Montmartre's bohemian milieu by its poets and painters. They transformed the condemned and executed anarchist activists into victims of social conditions, into martyrs for a future humanity and prophets of a corrupt, decadent capitalist society's ineluctable demise. Following the execution of Ravachol in 1892, the Symbolist poet Paul Adam vociferously proclaimed:

> After all the judiciary deliberations, the newspaper reports and the calls for legalized murder, Ravachol still remains the propagator of the grand idea of those ancient religions who preferred to seek individual death for the benefit of the Good of the world; the abnegation of the ego, of life and reputation for the exaltation of the poor, the humble. He is definitively the Renewer of the Essential Sacrifice.[23]

Dance at the Moulin de la Galette
photograph *c.* 1900
Archives Roger Viollet

Admired and revered after his death, Ravachol was celebrated popularly as well, as a new verb, *ravacholiser*, was coined to describe his activities, ballads honored him, and the dancers of Montmartre danced to his name:

> *Dansons la Ravachole!*
> *Vive le son, vive le son,*
> *Dansons la Ravachole,*
> *Vive le son*
> *De l'explosion!*
>
> *Let's dance the Ravachole!*
> *Long live the sound, long live the sound,*
> *Let's dance the Ravachole,*
> *Long live the sound*
> *Of explosions![24]*

Ravachol received the particular adulation of writers and artists who dedicated verses and pictures to him, then presented them in exhibitions and literary periodicals to the very bourgeois audience targeted by anarchist bombs and argument. The act of writing a poem or painting a picture was viewed as analogous to the explosion of bombs as a means of furthering the anarchist program:

> The poem, in so far as it is a creative act, is revolutionary. It is a form of direct action that calls into question the established order by the simple fact that it affirms the artist's dignity, liberty and power to create beauty in opposition to the sterile ugliness of the present day ... The fact alone of bringing forth a beautiful work, in the full sovereignty of one's spirit, constitutes an act of revolt and denies all social fictions ... Thus, consciously or not — but what does it matter? — whoever communicates to his brothers in suffering the secret splendor of his dreams acts upon the surrounding society like a solvent and makes all those who understand him, often without their realization, outlaws and rebels ... Good literature is an outstanding form of propaganda by the deed.[25]

Such an art of anarchist opposition rooted in the independence of the act of creation and the rejection of rules countered other anarchist's demands for an *"art social"* capable of addressing the proletariat immediately through naturalistic representations of existing social conditions

Paul Signac

APPLICATION DU CIRCLE CHROMATIQUE
DE CHARLES HENRY, 1889

(Application of Charles Henry's Color-circle)

and a projected utopian future. In the anarchist periodical *La Révolte*, published by Jean Grave, the ex-shoemaker who was one of French anarchism's chief publicists, the Neo-Impressionist painter Paul Signac accordingly aligned anarchism with the progressive painting styles loosely grouped together as "impressionist":

It ... [is] thus a mistake — committed all too often by the best-intentioned revolutionaries ... — to make it a standard demand that works of art have a precise socialist thrust, for that thrust will appear more strongly and more eloquently in the pure aesthetes, revolutionaries by temperament, who leave the beaten path to paint what they see, as they feel it, and who very often unconsciously deal a solid blow of the pick to the old social edifice that, worm-eaten, cracks and crumbles like an old, deconsecrated cathedral.

... With their new technique, diametrically opposed to hallowed rules, [the Impressionists] showed the vanity of inalterable practices; by their picturesque studies of the workers' quarters of Saint-Ouen or Montrouge, sordid and dazzling, by the reproduction of the broad and curiously colored movements of a laborer next to a sandpile, of a smith in the incandescence of a forge, or better yet, by the synthetic representation of pleasures of decadence — dance halls, chahuts, circuses ... — they bring their testimony to the great social trial under way between workers and capital.[26]

Paul Signac
View of Montmartre, 1884
oil on canvas, 13 1/8 × 10 in. (33.5 × 25.5 cm)
Musée Carnavalet, Paris

Facing Page:
Au café: le consommateur et la cassière chlorotique, c. 1898/99
(At the Café: The Customer and the Anemic Cashier)
oil on cardboard
20 1/4 × 23 5/8 in. (51.5 × 60 cm)
Kunsthaus Zürich; Dortu P. 657

Signac's argument is two-pronged. It demands artistic innovation that breaks and rejects, much as anarchism does socially and as a clear analogue to it, the established artistic order and practice, notably the post-Renaissance tradition of illusionism. But it also sees particular value in representations of contemporary subjects, most notably the life and fate of the working class and, very significantly, the decadent pleasures of the contemporary capitalist society he viewed as on the verge of collapse. The inventory of subjects corresponds less to what Signac and other Neo-Impressionists were painting in 1891 and more to their work of the later 1880s, coinciding with the rise of French anarchism after restrictions on political activity were lifted

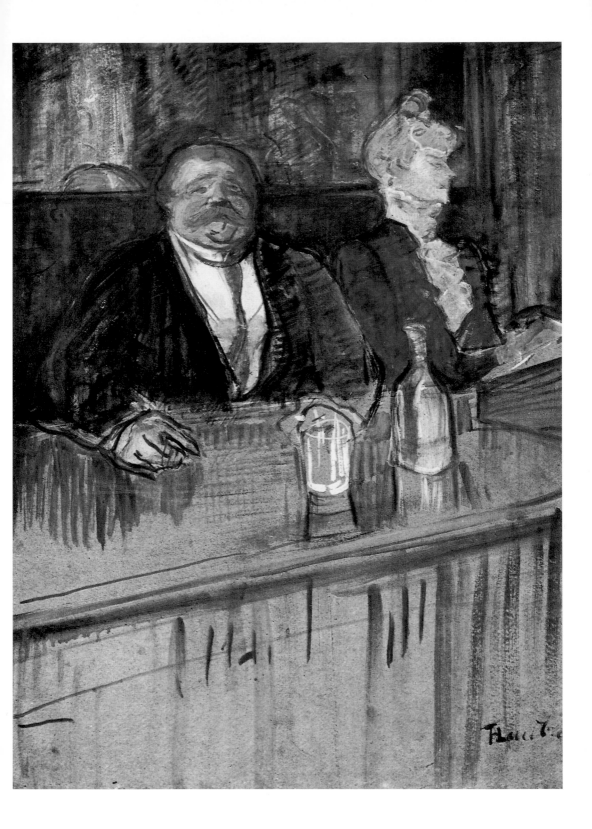

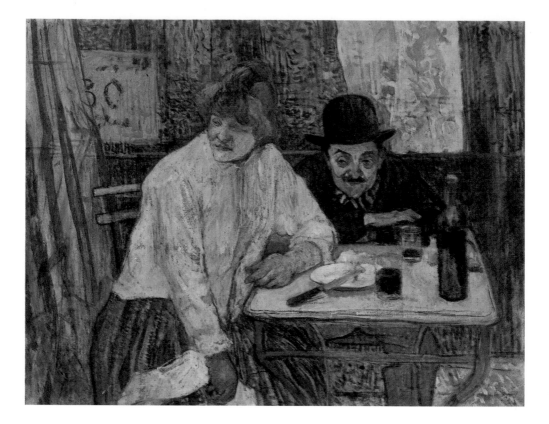

A LA MIE, 1891
oil and gouache on cardboard,
21 1/8 × 26 3/4 in. (53.5 × 68 cm)
Museum of Fine Arts, Boston; Dortu P. 386

in 1881 and preceding the series of *attentats* that shaped its public perception during the 1890s. When linked with a sincere, independently formulated, progressive, revolutionary, and future-oriented technique, Signac indicated, studies of the proletariat and of entertainment in a declining society offered positivist observation and personal testimony such as could form in their audiences a critical awareness of the contemporary human condition and the need for justice. Art seen this way could function in a process of anarchist education and humanist reform.

There is, I believe, a clear correlation between Toulouse-Lautrec's work of the later 1880s and the fusion of progressive style and "anarchist" subjects — proletarian motifs and popular entertainment — Signac identified as revolutionary in artistic as well as social effect. It is possible, although unlikely, that this may be due to a process of emulation, of Toulouse-Lautrec adopting motifs that had currency as a path to acceptance and recognition

without taking into account any ideological ramifications. His selection of prototypes of style and content among those artists most immediately identified by public and critics with left-wing ideologies while ignoring more neutrally received ones necessitated that his own paintings take on a similar association, that they be seen as anarchist in spirit at least. The linkage could not be avoided. It appears to have been consciously sought, then fostered.

There is little written documentation of Toulouse-Lautrec's political convictions, however. During a time of extraordinary political agitation and activity in France when artists and writers readily lent their names to varied political and social causes, he stood apart by avoiding doing so. No petitions, no political manifestos, no ideological statements bear his signature. He sought the company and support of Signac, other artists, performers, and especially critics who publicly proclaimed and supported their anarchist convictions, but he did not join them in their political projects. Possibly, the historical significance of the family name and the desire to avoid scandal for it contributed to this apolitical pose. There can be no doubt, however, that Toulouse-Lautrec had little respect for the Third Republic, ridiculing its institution of Bastille Day as a national holiday, for example, with a punning reference to "this stupid fourteenth of Juliette holiday" in which the feminization of *juillet* into *Juliette* seems to imply frivolity, weakness, and lack of manliness.[27] Continued adherence to his family's monarchist convictions may underlie this denigration of the celebration of the French Revolution, but it would also not be contrary to anarchist attitudes. Indeed, other monarchists and aristocrats notably saw no contradiction between their class status or royalist convictions and their support of anarchist writers and artists or even of political alliances with anarchist activists. Rejection of the existing political system and social order in a manner far from alien to anarchism can be attributed to Toulouse-Lautrec with high certitude, even if a precise configuration cannot be determined.

His paintings and drawings, as well as his chosen places of exhibition, nonetheless seem to ally him most closely with the political left. In part, as Signac's article

makes apparent, this is because the left largely coopted France's progressive art when it identified stylistic innovation and contemporary subjects as fundamentally revolutionary, at least unconsciously furthering the overthrow of the existing social order. Therefore, when Toulouse-Lautrec depicted proletarian types and the urban *vie sur le pavé* of Aristide Bruant's "Dans la rue," when he displayed them in cabarets and restaurants or published them in popular periodicals, his works participated in the political discourse of radical opposition in the Third Republic on the side of socialism and anarchism whether or not he otherwise voiced his support for them.

In 1888 and 1889, Toulouse-Lautrec added Belgian and Parisian avant-garde exhibition societies to the sites where he displayed his work, thereby shifting the focus of his career to more accepted, if avant-garde, venues of art display. In the summer of 1887, he was invited to send works to Les XX in Brussels, which yearly organized overviews of contemporary progressive European art and fostered a bond of radical art and radical politics. He sent eleven works, portrait types and a circus scene. More adventurous, but also in keeping with the identity he had already shaped in Paris, were the works sent the next year to the fifth Salon des Indépendants, the first major group exhibition in which he participated in Paris. A portrait of the banker Henri Fourcade, clad in formal black evening clothes with top hat, at the masked Opera Ball was paired with the large painting *Au Bal du Moulin de la Galette* (see p. 54). Conceptually, despite their apparent difference of genre, the two function to contrast bourgeois with lower-class evening entertainments, the respected with the déclassé, the fashionable with the vulgar, formality with spontaneity, disguise and artifice with simplicity and naturalness. Of the two, the dance hall scene was the larger and more ambitious. Painted on canvas rather than cardboard, its composition published as a drawing in *Le Courrier français*, and repeatedly exhibited by Toulouse-Lautrec during the following years, it became a virtual signature piece of his art.

Thematically, this painting returned to the depiction of dance halls such as Toulouse-Lautrec had featured

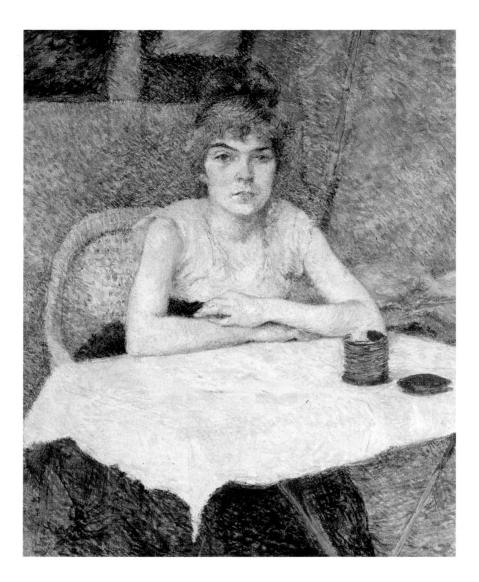

Poudre de Riz, 1887

(Rice Powder)

oil on canvas, 22 × 22 7/8 in. (56 × 58 cm)

Rijksmuseum Vincent van Gogh, Amster-

dam; Dortu P. 348

on the cover of *Le Mirliton* in 1886 as his public career
was beginning. He continued to explore the theme in in-
formal drawings and painted sketches during the inter-
vening time, but never with the ambition of his Paris ex-
hibition premiere. In this context, the Moulin de la Galette
painting both concluded and inaugurated phases of his
career, and served as a signpost of the twenty-four-year-old
artist's self-proclaimed artistic maturity. He repeated the
frieze of background figures employed in the 1886
grisaille painting, but eliminated virtually all reference to
a middle ground; the four foreground figures are set off

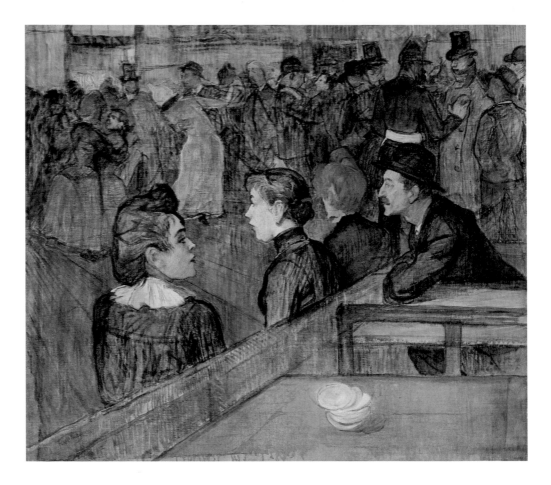

Au Bal du Moulin de la Galette, 1889

(At the Moulin de la Galette Dance Hall)

oil on canvas, 34 7/8 × 39 7/8 in.

(88.5 × 101.3 cm)

The Art Institute of Chicago, Mr. and Mrs.

Lewis Larned, Coburn Memorial Collection;

Dortu P. 335

immediately against the frieze of dancers extending across the entire width of the painting, with only an indeterminately placed group of a policeman addressing a top-hatted man serving as a transition at the right. The viewer is made to participate in the scene by being positioned at a wooden table with a pile of bowls for serving mulled wine balanced precariously on it and by being made to look across the diagonal of a railing directly at the profile of a woman. (In a review of the Indépendants' exhibition for *La Vogue*, the anarchist critic Félix Fénéon described this woman as "porcine"). She is flanked by two others, one red-haired with her back to us, and another again in profile (Fénéon: "That pretty profile of a young gigolette with collarette, her shrewd eyes a bit clouded by alcohol").[28] Behind them, at the next table, a mustached man in dark suit and bowler hat, "Alphonse" according to

Fénéon, using an argot term for a "swell" or "pimp." Fénéon recognized and decoded the "types" that Toulouse-Lautrec previously depicted; now such studies had been collaged into a grand composition, a collection of disparate pieces brought somewhat awkwardly together. A trio of prostitutes and their keeper thus mark the foreground, none in communication with the others, each staring in melancholic isolation, and we as viewers become implicit evaluators of the three, potential customers much like the isolated men dotted throughout the frieze of waltzing dancers in the background. The scene is in muted tones — greens, reds, browns, whites tinged with gray — in runny, turpentine-thinned, washlike paint that sinks into the beige-toned canvas, significant portions of it left bare between the fluent patterned strokes of dull and muddied color. As profiles and silhouettes are accented by outlines and details are rendered with strokes of color, figures and forms lack corporeality and synthesize with the surface and material of the canvas, their illusions dematerialized as the painting itself is made corporeal in Toulouse-Lautrec's application of contemporary avant-garde efforts. The painting thereby also follows the formulation Signac identified as fulfilling the codes of anarchism.

The dulled colors and streaks aid in giving the painting an atmosphere of squalor and earthy grime, as if the "coloration sullied with ink"[29] Fénéon saw somehow covered people and filled the dance hall in equal measure. Oil paint's celebrated noble brilliance and sensual viscosity are denied and fundamentally proletarianized, made analogous to the dance hall's lower-class patrons, while the seeming haste of the brush strokes offers a quality of impermanence. The painting is, therefore, less a celebration of its art than a fundamental antithesis to the art of painting, vociferously an anti-painting, a virtual bomb in the social order of art's history, its paint dripping from the bottom edge, threatening simply to dissolve and disappear, to leave only a soiled canvas behind. *Au Bal du Moulin de la Galette* is a "synthetic representation of pleasures of decadence," to employ Signac's terminology, a pessimistic view onto a society in decay, its very proletarian base disintegrating, its members alienated from one another except in the embraces of dance, its bodies for sale.

Monsieur Fourcade, 1889
oil on cardboard,
30 3/8 × 24 3/8 in. (77 × 62 cm)
Museu de Arte de São Paulo; Dortu P. 331

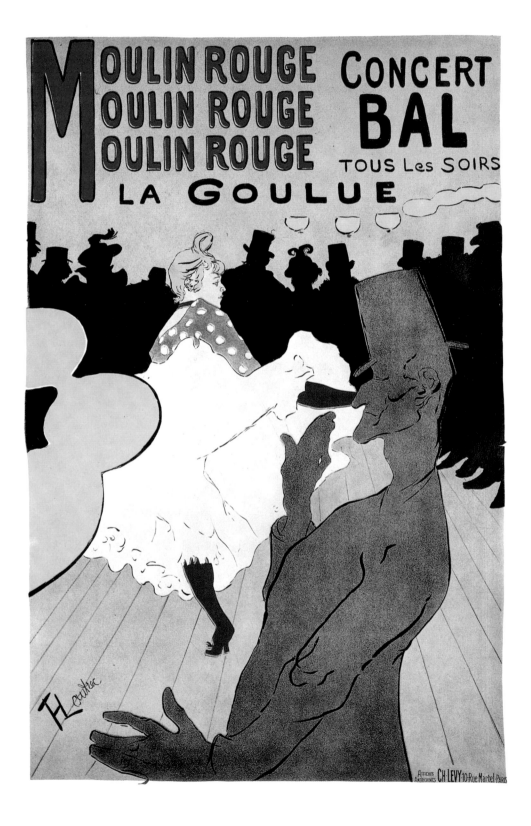

CHANSONS, DANCES, AND POSTERS: FROM THE MOULIN DE LA GALETTE TO THE MOULIN ROUGE

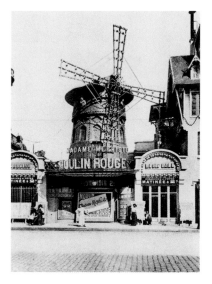

The men Toulouse-Lautrec shows dispersed among the women in *Au Moulin Rouge* represent a different social milieu from those seen in the dance hall paintings of the Moulin de la Galette. There, they were predominantly of the lower classes, artists or bohemians; here, they are clearly middle or upper class, businessmen and bankers in top hats and fashionable clothing. They, rather than the inhabitants of Montmartre, were the customers directly targeted by the Moulin Rouge, the first Montmartre dance hall built specifically to appeal to middle-class and society Paris. A report of the opening on Sunday, 6 October 1889, makes this apparent:

> Last night the whole of Paris was [at the Moulin Rouge] to celebrate the opening and the show was not only on the stage, but also in the audience. On view were Their Highnesses Prince Stanislas de Poniatowski and Prince Troubetzkoi, the Comte de la Rochefoucauld, Messieurs Elie de Talleyrand and Alexander Duval ... together with the flower of literature and the arts, having the time of their lives ... When they created what they called the "first Palace of Woman", Messieurs Oller and Zidler were playing for high stakes. Yesterday ... they promised that this establishment was going to become the most magnificent of all the temples of dancing and of music.[30]

An entrepreneur, owner of circuses, racetracks, betting parlors, and amusement parks, Joseph Oller financed the Moulin Rouge on the former site of the Reine Blanche dance hall on the place Blanche; Charles Zidler, director of the Hippodrome circus, served as manager and director until 1892. Whereas the Moulin de la Galette's trademark windmills were remnants of Montmartre's agrarian past, with the barnlike dance hall added, significantly the large red mill that marked the Moulin Rouge's entrance was artificial, nonfunctional, designed like the remainder of the façade and decor by the Montmartre artist Adolphe Willette, previously associated with the Chat Noir cabaret and illustrator for the anarchist periodical *Le Père peinard*. Brightly illuminated, its slowly turning sails

Moulin Rouge on the Place Blanche, photograph *c.* 1890

Facing page:
MOULIN ROUGE, LA GOULUE, 1891
color lithograph, poster, 75 ¹/₄ × 45 ¹/₄ in.
(191 × 115 cm);
Delteil 339 II

outlined in electric lights, an animated figure of a miller gazing out a window, flanked by the false façades of a Gothic castle and a Norman cottage from whose windows the miller's wife waved, the mill offered an artificial link with Montmartre's past, but served primarily as the highly successful trademark of the new dance hall, easily recognized and memorable, an artificially archaic intruder into the urban milieu that surrounded it. Behind the façade were variety shows in Spanish, Dutch, and Norman settings, a large garden café with a stage as well as a huge, hollow elephant-shaped structure in which belly dancers performed, and the grand dance hall itself, brightly lit with both electric and gas lights, featuring an orchestra, tables on platforms surrounding the dance hall, and an encircling promenade. The major advertised attraction, however, was the *quadrille naturaliste* and the cancan with the most celebrated and notorious dancers of Montmartre, all lured away from previously existing dance halls, performing on the dance floor in the midst of the swarm of milling patrons.

Just as Oller and Zidler appropriated dancers with established reputations, their very establishment of the Moulin Rouge was intended to siphon off the clientele the older dance halls had recently built up, particularly the middle- and upper-class visitors who now frequented the butte's entertainment establishments. Numerous illustrations and articles in the popular press, novels, and the publicity produced directly by dance halls, cafés, and cabarets addressed precisely the types of patrons present at the Moulin Rouge's opening. Top hats replaced the workers' "melons" when entrance fees of three francs were charged, not the Moulin de la Galette's fifty centimes. With luxurious decor that conjured up Spain, Normandy, or the Middle Ages, the Moulin Rouge offered Parisians and a growing number of foreign tourists led there by new guidebooks on Montmartre and its nightlife a retreat from the everyday into a Disney-esque hyperreality whose supreme revelation was a fictionalized demimonde embodied in the *quadrille naturaliste* and its "natural" lower-class performers in the excited choreographed display of their sexual allure.

AU MOULIN DE LA GALETTE, 1891
(At the Moulin de la Galette)
oil on cardboard,
31 $^1/_2$ × 27 $^1/_2$ in. (80 × 70 cm)
Private collection; Dortu P. 388

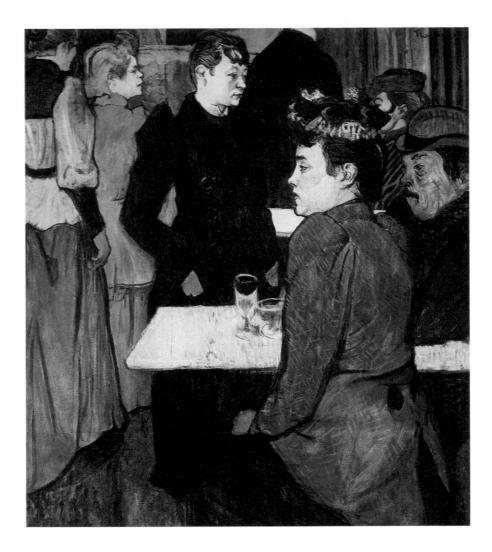

Un Coin du Moulin de la Galette, 1892
(A corner in the Moulin de la Galette)
oil on cardboard, 39 ¹/₂ × 35 ¹/₈ in.
(100.3 × 89.1 cm)
National Gallery of Art, Washington, D.C.,
Chester Dale Collection; Dortu P. 429

In the "the most magnificent of all the temples of dancing and of music,"[31] Oller and Zidler also followed the examples of Bruant's Mirliton and Salis' Chat Noir by displaying thematically appropriate artworks to the Moulin Rouge's clientele in the foyer, near the bar. Paintings by Willette could be seen there, but also a circus painting by Toulouse-Lautrec, purchased by Zidler after it had been shown at the 1888 Les XX exhibition. The circus theme may have appealed as a reference to the Moulin Rouge management's other interests, but the "modern" painting by a young, largely unknown artist also suggested engagement with the contemporary and up-to-date, with artistic

innovation as an extension of the Moulin Rouge's commercial modernity. Willette, the older Montmartre painter, still working in a modified neo-Rococo mode, was juxtaposed with a young artistic revolutionary, in effect bringing Montmartre's artistic past and future together in a present sponsored by the Moulin Rouge.

The association of dance hall and Toulouse-Lautrec was cemented further, moreover, after the 1890 Salon des Indépendants, when *Dressage des nouvelles, par Valentin le Désossé (Moulin-Rouge)* was added to the collection on display above the bar. Begun shortly after the Moulin Rouge opened in 1889, it shows us the dance floor as people, predominantly men, stand and walk about while Valentin le Désossé rehearses an auditioning dancer. As we look onto the scene, with floorboards signaling perspectival depth, our organizing eye level is approximately at the height of the shoulders and feather boa of the foreground woman in pink. This enables us to see back past the friezelike arrangement of patrons toward a background of tables, alcoves, lights, and windows opening onto the trees in the garden. The views of nature and its colors become entrapped in the artifice within, subsumed by the discoloring artificial illumination, shaped into aspects of the decor, shading faces with anomalous touches of green. In addition to Valentin le Désossé, several of the men in the background can be identified as friends of

Toulouse-Lautrec. The women, even the dancer, all remain unknown, however, despite the portraitlike features of the foreground woman clothed in pink. They function in their anonymity largely as accents of color among the uniformly black and brown male clothing. It is the color of the foreground woman, the large area of dulled pink her dress imparts to the scene, in conjunction with the very calm quietness of her pose, her eyes passively downcast, seemingly indifferent to the dance taking place before her, that lend her a unique presence; they separate her from her surroundings and force her to be seen, letting her serve as an advertisement for herself, an alternate attraction to the dance performance.

Themes of social classes mingling, of sexuality, and of carnal display reappear to characterize the milieu of the Moulin Rouge, as Theo van Gogh recognized when he wrote to his brother that "de Lautrec has a large painting [at the Indépendants] that comes off very well. Despite its scabrous subject, it is first-rate."[32] Less impressed was the anonymous critic of *La Laterne* on 21 March, who however saw the same "scabrous" content and described it more fully:

> By M. Toudouze-Lantrec [sic], a *quadrille naturaliste*. It takes place at the Moulin Rouge. A girl with a shock of red hair, her shoes with heels worn down, hops about while displaying her red stockings. Valentin le Désossé oversees this coarse exercise and we get the impression that under his competent direction this rustic wench breaking out of her shell will be transformed into a star rivaling La Goulue. This lesson is being followed attentively by a number of besotted swells, dilettantes of this type of spectacle.

As in prior paintings, Toulouse-Lautrec in *Dressage* exploited his audience's familiarity with popular depictions of Parisian types, their connotations and their signs. The critic for *La Liberté* thus ignored the title's identification of Valentin le Désossé and instead gave him a name linked to demimonde and bohemian fops: "Adolphe [who] has taken his conquest of the day to a dance hall, and there, under the 'shocked' eye of the bourgeois, he gives a dance lesson to the young woman."[33]

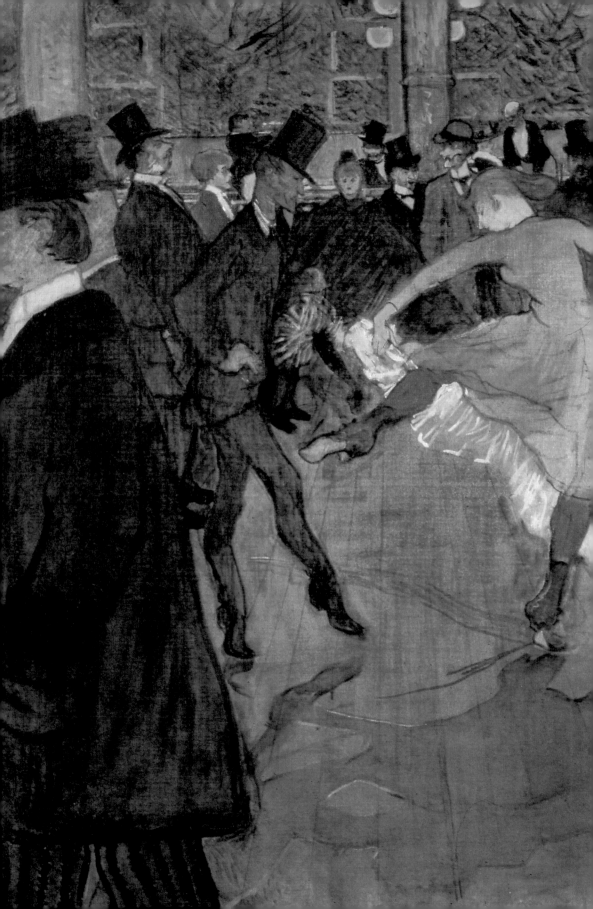

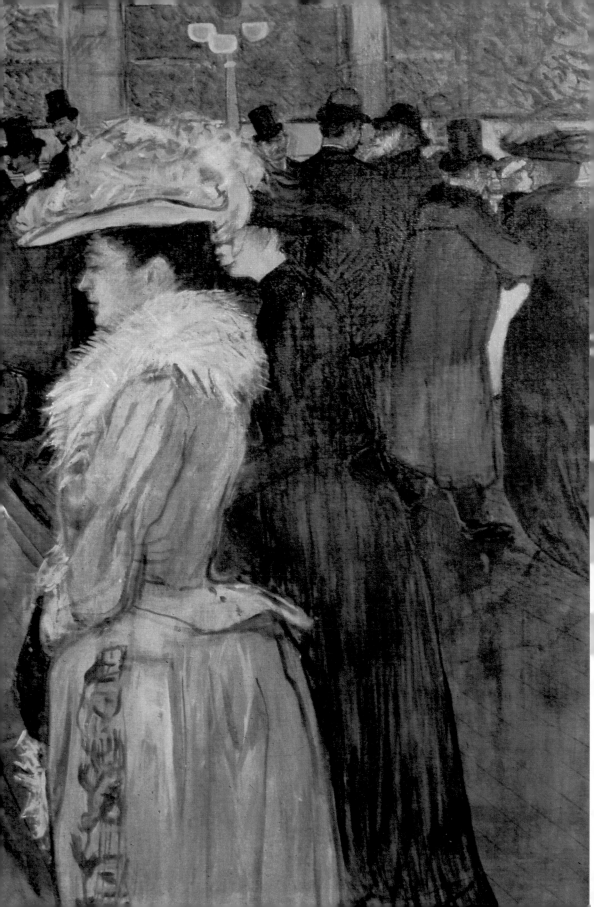

An accent on sexuality appears throughout the reactions, whether the critic is favorable or antagonistic to Toulouse-Lautrec's or other progressive artists' stylistic practices. Indeed, surprisingly little is said of the manner of painting. The sketchiness and caricaturesque that are combined seemingly arbitrarily with more finished, even naturalistic renditions within the same painting; the accented outlines, visible underdrawing, and corrections; the use of drawing as a substitute for modeling; and the thin, dulled colors applied in a translucent, flat wash over a brown-tinged canvas — none of this was discussed, as the motif dominated all consideration. It is not that other artists failed to present dance hall scenes — *L'Art français'* critic complained of all the "young artists" whose "heroes of preference call themselves Valentin le Désossé or La Goulue"[34] — but Toulouse-Lautrec's scenes drew critics' attention more and perhaps allowed a more defined reading of what was depicted. None, not even so astute a critic as Fénéon, spent much time considering Toulouse-Lautrec's technique; instead, they discussed Montmartre, the Moulin Rouge, and the people who frequented them. There may be implicit in this phenomenon a statement concerning the aptness of Toulouse-Lautrec's mode of painting for the subject matter he chose to depict, an appropriate matching of a style and a milieu both perceived as lâches and needing no further commentary. Oller's purchase of *Dressage* and its display at the Moulin Rouge were but appropriate extensions of this process of matching identification.

The linkage of Toulouse-Lautrec's art with the commercial enterprise of the dance hall became yet more tightly fused the next year, when he accepted Zidler's commission to produce a lithographed poster for the Moulin Rouge despite his lack of experience in lithography. As part of the extensive publicity efforts, using all advertising means available, announcing the dance hall's opening was a large-scale, color lithographed poster by Paris' most celebrated poster artist, Jules Chéret, a Knight of the Legion of Honor also closely allied to the bohemian and entertainment world of Montmartre. Chéret's three-color posters, like the physical and commercial conception of the Moulin Rouge generally, fused modernity, innovation, established

artistic quality, and commercial effectiveness in a mixture guaranteed to attract Paris' attention. Smiling, scantily clad, inviting women dominated them, as did the silhouetted emblem of the red windmill, to offer an effective foretaste of varied entertainments — "choreographic celebrities" dancing the cancan or engaged in donkey races, as well as the unannounced but implicit and expected presence of "Aphrodite's daughters." In his first poster, *Moulin Rouge, La Goulue*, 1891 (see p. 56), Toulouse-Lautrec closely followed Chéret's example, but — as he did with the drawings and paintings of Degas, Forain, or Raffaëlli — also evoked a synthetic vision of his subject which exceeded Chéret's only recently established innovations.

In place of Chéret's neo-Rococo "Chérettes" stylized into pretty anonymity, Toulouse-Lautrec's poster shows the dancers La Goulue and Valentin le Désossé, already featured in his first *Le Mirliton* cover in 1886. Both performed together at the Elysée Montmartre dance hall until hired away by the Moulin Rouge late in 1890, La Goulue reportedly for 3,750 gold francs. Born in 1866 in Clichy,

Jules Chéret
POSTERS FOR THE MOULIN ROUGE, 1889–90
Private collection, Paris

Louise Weber, known as La Goulue

near Paris, of Lorrainois parents, her father a carpenter, baptized Louise Joséphine Weber, La Goulue was described in *Gil Blas* in 1891 as "petite, rosy-skinned, chubby and beautiful all over ... her shoulders pearly and her head roguish with golden hair whose heavy braid is piled high to take on the appearance of a helmet." Her dance, in turn, was characterized as wild and savage, with high-swung legs endangering the hats of onlookers and her embroidered pantaloons displayed so as to offer male admirers hopes of seeing an opening, a "little piece of ruddy flesh" visible above her stockings to "radiate with the heat of molten steel" among her spectators. The dance was a hide-and-seek show of La Goulue's flesh amid myriads of swirling cloth, of white lace underskirts, other undergarments, and dark stockings.[35]

The dance is the focus of the poster. In a vertical compositional formula based on *Dressage*, La Goulue replaces the apprentice dancer and reverses her pose, Valentin le Désossé is pulled to the foreground where his large shadowy figure takes the place of the woman in pink as he gestures back toward the *chahuteuse*, and the frieze of onlookers is transformed into a lively black silhouette. A large study, nearly the size of the poster in which Valentin le Désossé's figure is virtually life-sized, preceded the lithograph, functioning as intermediary between painting and poster in a process that filtered out detail and accented increasingly synthetic simplicity. To the stylistic influences of his paintings, the artist here added in a personalized, eclectic mix Chéret's color and poster technique, the silhouetted figures of Japanese prints as well as of the shadow plays popular at the Chat Noir cabaret, and the radical lack of detail and the flatness and outlining of Gauguin's Synthetist followers. As in his paintings, colors were muted, with the pale gray or ochre paper tone identifying La Goulue's pantaloons, but the enhanced reduction of pictorial components marked a vital shift in Toulouse-Lautrec's work, attuning it to the Synthetist idiom. According to the extraordinarily concise definition offered in 1893 by Fénéon, "By means of drawing which is not a carbon copy of reality but an ensemble of signs that suggest it, [Toulouse-Lautrec] immobilizes life in unexpected systems of emblems."[36]

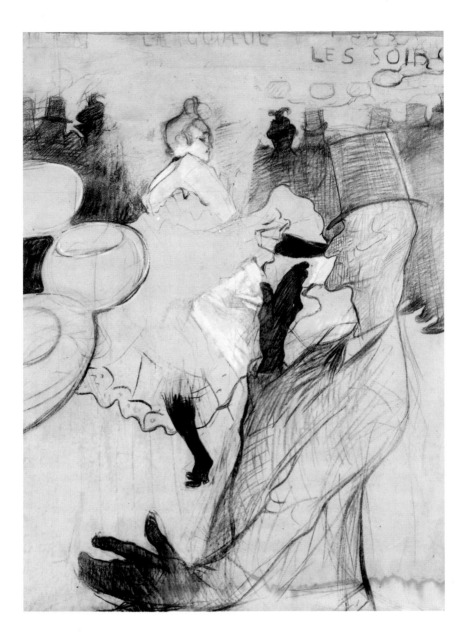

La Goulue et Valentin le Désossé, 1891
(La Goulue and Valentin, the 'Boneless One')
charcoal and oil on dark cream wove paper,
60 5/8 × 46 1/2 in. (154 × 118 cm)
Musée Toulouse-Lautrec, Albi; Dortu P. 402

To his mother, an obviously pleased Toulouse-Lautrec wrote on 25 January 1892 that "they're being very nice to me in the newspapers after my poster."[37] Most important for him was the first extended critical discussion of his work, an essay by Arsène Alexandre, a critic noted for his advocacy of Impressionism and support of Neo-Impressionist theory, in *Le Paris*, "a very republican paper (don't tell the family) ... in which they unveil my person

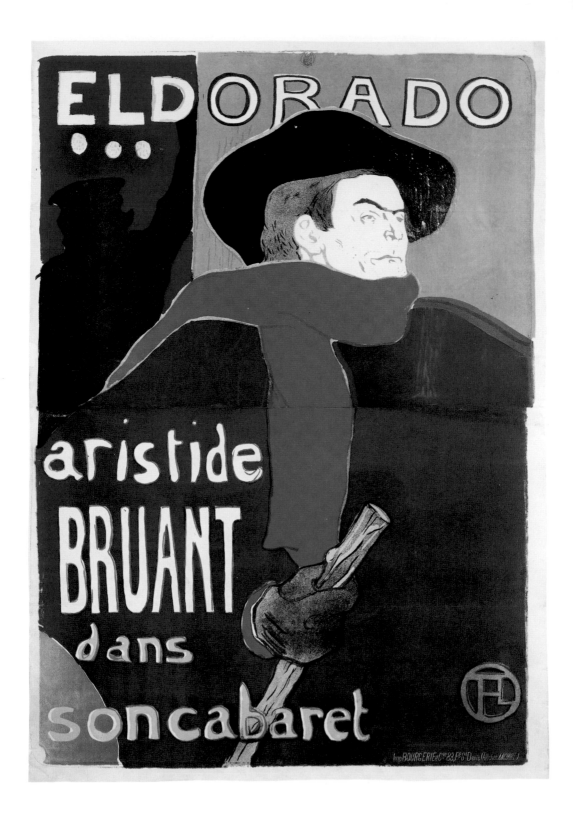

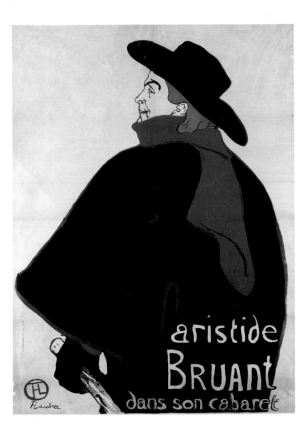

without holding back a single detail." The review discusses the poster and its innovations, briefly considers the paintings displayed at the Moulin Rouge, and ends with a lengthy characterization of the artist.[38] Through the Moulin Rouge poster, Toulouse-Lautrec as artist received his first major public acclaim.

There was, beginning in the late 1880s, a deluge of posters in Paris. Chéret's introduction of increased color made them an appealing, eye-catching, and effective means of advertising in the Third Republic's emerging consumer society. Moreover, in 1890 a retrospective exhibition of Chéret's posters celebrated them less as commercial art than as artworks in a more limited sense, as examples of lithography and printmaking. The poster thereby ceased to be viewed solely as applied art and became an appropriate medium for artists, not just technicians and craftsmen. The poster, it was argued, brought

THÉOPHILE STEINLEN
Cover for *Le Mirliton*, 9 July 1893;
at the left is the poster illustrated above right

ARISTIDE BRUANT DANS SON CABARET, 1893
(Aristide Bruant in his Cabaret)
color lithograph, poster, 50 1/8 × 37 3/8 in.
(127.3 × 95 cm); Delteil 348 II

Facing page:
ELDORADO, ARISTIDE BRUANT, 1892
color lithograph, poster, 53 7/8 × 38 in.
(137 × 96.5 cm); Delteil 344

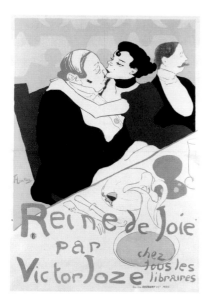

art into the streets, made art available to the populace, and therefore broke down the hierarchies under which art, like society, suffered. In an argot-filled essay, Fénéon laid out the poster's appeal in the anarchist periodical *Le Père peinard*:

> It's not for me — I won't make a fool of myself in exhibitions and get a stiff neck from staring at dirty underwear in gold frames.
> Instead of that idiocy, let's imagine you're in the street: you piss against a wall, you stroll with your pal, you're on your way to the job or on the way home, and at the same time, without worrying about it, you glance at posters ...
> It's an open-air exhibition, all year long and all along the street ... and that's real art, by God!, and it cries out, it's part of life itself, it's art that doesn't fool around and real guys can get it.

He singles out Chéret for praise, not neglecting to imply the poster's analogy to anarchist dynamite as a social force: "Everything's beaten, powdered and sprinkled with flamboyant colors, — it's like dynamite and as fresh as a bouquet of flowers." As representing the future of the poster, however, he names Toulouse-Lautrec:

> There's nothing false in either his drawing or his color. White, black, red in great slabs, and simplified forms, — that's his bag ... but it knocks you off your feet with its daring, its cheek, its impact, and it's a hard nut to crack for those who want to be spoon-fed with nothing but sweet mush.

Fénéon instructs his readers on how to remove posters from the walls of the city and hang them in their rooms: "A Lautrec or a Chéret at home, that's what'll illuminate things, by God!"[39] In the modern poster, the demand for an anarchist artwork found its resolution, and Toulouse-Lautrec's more than any others served as an artistic "propaganda by the deed."

In good part, this was again because of the subjects of the posters, not only because of the undermining

REINE DE JOIE, 1892

(Queen of Joy)

color lithograph, poster, 53 3/4 × 36 3/4 in.

(136.5 × 93.3 cm); Delteil 342

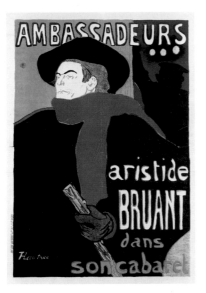

color lithograph, poster, 52 5/8 × 36 1/8
(133.8 × 91.7 cm); Delteil 343

innovations of form and the revolutionary rejection of uniqueness and settings dedicated to art. The poster for La Goulue, which according to an anarchist view offered graphic display of the pleasures enjoyed by a society in decay, was followed in 1892 by *Reine de Joie*, the advertisement for Victor Joze's scandalizing novel of Jewish bankers, depravity, and prostitution. In Fénéon's description, "There's nobody else like him to capture the mug of gaga capitalists sitting at a table with some little whore who knows what's what, and who'll smooch their ugly snouts to make 'em stand up."[40] Further fitting an iconography of anarchist support, then, were the posters publicizing Aristide Bruant's cabaret performances, especially as they were displayed in the streets of Paris, directly confronting the city's fashionable inhabitants.

Although he did not himself embrace anarchism, Bruant's songs were frequently sung at anarchist gatherings, and his anti-bourgeois attitude was readily adapted to an anarchist message. Toulouse-Lautrec's posters of 1892, however, document a significant transformation in the sites of Bruant's performances as they announce his cabaret shows at luxurious *cafés-concerts* on the Champs-Elysées, not in Montmartre. Much as the Moulin Rouge brought fashionable Paris to Montmartre, by 1892 fashionable Paris was bringing Montmartre to itself. While it could be argued that thereby the undermining social ideologies of the butte were being implanted directly into the bourgeois milieu, thereby subverting it, a process of *haute culture* assimilating its antagonists, celebrating them and thereby reducing their reformatory effectiveness was also at work. Much the same thing occurred in the reception of the poster, which Fénéon and others identified as a utopian art form for the people. By 1891, when Toulouse-Lautrec designed his Moulin Rouge poster, art dealers were publishing catalogues of available posters, posters were being printed in limited editions on heavy paper mounted on canvas, and exhibitions devoted to posters were being held. Shortly thereafter, the periodical *La Plume* devoted an issue to posters, books on posters were published, and several periodicals for poster collectors were founded. Poster collectors became a visible component of the art market. This *affichomanie* to which his own posters

provided a major impulse was exploited by Toulouse-Lautrec as he printed impressions of his posters without the lettering, some personally signed and some numbered as prints would have been, and he exhibited them along with his paintings, thereby declaring them equal, at the exhibitions of Les XX and the Indépendants. Much like Bruant's appearances at the Ambassadeurs, near the Champs-Elysées, in 1892, these were gestures with double meaning, satisfying the new *affichomanie* of the art market but also insisting on the placement of commercial art and advertising in the milieu of the fine arts, thereby subverting or extending the concept of art itself.

Despite the praise his posters received, Toulouse-Lautrec, unlike Chéret, did not devote his energies predominantly or even frequently to them. The ones he produced — twenty-eight between 1891 and 1896, only two thereafter — appeared largely as incidental works and personal favors for friends, and only secondarily as truly commercial efforts intent on effective advertisement in a mass market. (A single exception to this is the poster for the mass-circulation newspaper *Le Matin*'s serialization of the memoirs of a prison chaplain, *Au pied de l'Echafaud*, of 1893). In what they advertised, most addressed a limited, defined audience, not the broad populace Fénéon imagined: frequenters of Montmartre's music halls and *cafés-concerts*, readers of Joze's novels, subscribers to leftist cultural periodicals. Limited production and conscribed audience were acceptable, however, since for Toulouse-Lautrec there was never a question of dependence on his commissions for income. He remained the aristocrat, able to select his activity at will, even if his identity with commercial activity signaled — as did his very decision to be a professional artist — an ideological departure from the aristocracy's values. If we disregard their impact on other artists, the posters therefore gain significance largely from the way in which they contributed to the shape of Toulouse-Lautrec's artistic persona and public identity as they cemented him firmly to Montmartre's expanding entertainment industry, crowding out virtually all else.

Both the favorable critical responses and the publicity received by the Moulin Rouge poster, I believe, induced

Facing page:

AU PIED DE L'ECHAFAUD, 1893

(At the Foot of the Scaffold)

color lithograph, poster, 32 $^1/_2$ × 23 $^1/_4$ in.

(82.5 × 59 cm); Delteil 347 II

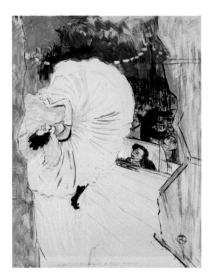

the artist to focus on further motifs from the dance hall during 1891 and 1892, in search of additional public acclaim not in additional posters, but in independent paintings and lithographs. The resulting suite of paintings, all executed on cardboard panels similar in size with thinned oils at times mixed with gouache, turned away from the dance stars as they performed and instead offered privileged, private views of them, deprived of music and the transforming excitement of dance, become mundane. A trio of paintings, exhibited at the 1892 Salon des Indépendants, offered variations on the depiction of La Goulue: she arrives at the dance hall, her arms entwined with those of her sister and her lover, the dancer La Môme Fromage (see p. 24); she parades alone, seen from the back, with her sister on the dance floor (see p. 77); and she walks arm in arm with a male dancer, resting between waltzes.

Reviewing the Indépendants in the republican paper *Le Voltaire* on 25 March 1892, Roger Marx, an art critic also highly placed as a government official in the Direction des Beaux-Arts, attributed a defining role to Toulouse-Lautrec, calling him "essential ... in today's art ... a thinker and a painter":

> He is the great analyst of feminine gesture, the great describer of woman's attitude, her walk, her poses; with the sharp, cruel, inexorable shrewdness of a Huysmans, he lets her confess to him, then tells all ... Literary considerations aside, you should not fail to affirm this in the three Moulin Rouge paintings that are certainly among the most extraordinary genre scenes ever shown since Brueghel the Elder and Jan Steen. You should not fail to affirm either the variety and the novelty of his presentation of personalities nor the quality of the ambience, the truly artistic indications of the surrounding scene, the reflections and the background.

It is notable that Toulouse-Lautrec was beginning to receive support not only from anarchist or other radical critics but also from those writing for bourgeois, republican papers. Having established a reputation with his posters, he was pushed to the forefront of critical attention

La Roue, 1893
(The Cartwheel)
black chalk and gouache on cardboard,
24 3/4 × 18 3/4 in. (63 × 47.5 cm)
Museu de Arte de São Paulo; Dortu P. 483

Facing page:
La clowness au Moulin Rouge, 1897
(The Clown in the Moulin Rouge)
color lithograph, 16 1/8 × 12 5/8 in.
(41 × 32 cm); Delteil 205

La Revue blanche, 1895
color lithograph, poster, 49 3/8 × 35 7/8 in.
(125.5 × 91.2 cm); Delteil 355

Facing page:
Au Moulin Rouge, La Goulue
et sa soeur, 1892
(At the Moulin Rouge,
La Goulue with her Sister)
color lithograph, 18 1/8 × 13 3/4 in.
(46.1 × 34.8 cm); Delteil 11

and support with amazing speed, identified by critics of anarchist as well as more moderate republican ideologies as an insightful, caustic commentator, having "an acute and personal vision" of contemporary mores, especially those of Montmartre's women. "For there is depth to that cruelty which constitutes Toulouse-Lautrec's talent," wrote Arsène Alexandre; "he thumbs his nose at life ... he makes fun of imbeciles and refuses to idealize prostitutes ... Under finery he immediately sees bestiality, under pretensions, stupidity, and he sees the animal in men and women."[41]

Toulouse-Lautrec exploited the women who entertained in Montmartre's music halls. Through their reputations, most frequently infamous, he advanced his own, supplanting artists such as Forain who had explored Paris' demimonde before him. The representations shift, however, between apparent sharp-eyed veracity, celebrations of beauty or grace, and coarsely vicious caricature, and not infrequently all three were applied in depictions of the same dancer or singer.

Exemplary are the depictions of the dancer Jane Avril, who used as her *nom du théâtre* the name of the French explosive favored in anarchist "propaganda by the deed," *La Mélinite*, when she first appeared at the Moulin Rouge in 1890. Red-haired, pale, tall, and slender; the illegitimate child of an Italian aristocrat and a French prostitute; a former patient of Dr. Jean-Martin Charcot's Salpêtrière asylum; a friend of avant-garde poets and other writers — Jane Avril was first portrayed by Toulouse-Lautrec in the series of paintings he devoted to the Moulin Rouge, its performers and audience in 1892. She appears in the backgrounds of several paintings, an identifiable onlooker or passerby, in four portrayals of her alone, in three posters, and in numerous drawings.

In what is perhaps the earliest of her portraits, she dances her signature dance, a free-form variant of an English jig mixed with elements of the *chahut*, in a tall painting on cardboard, its verticality accenting her slenderness, her face a contemplative mask, her ample white dress pulled up to display a dark petticoat and her

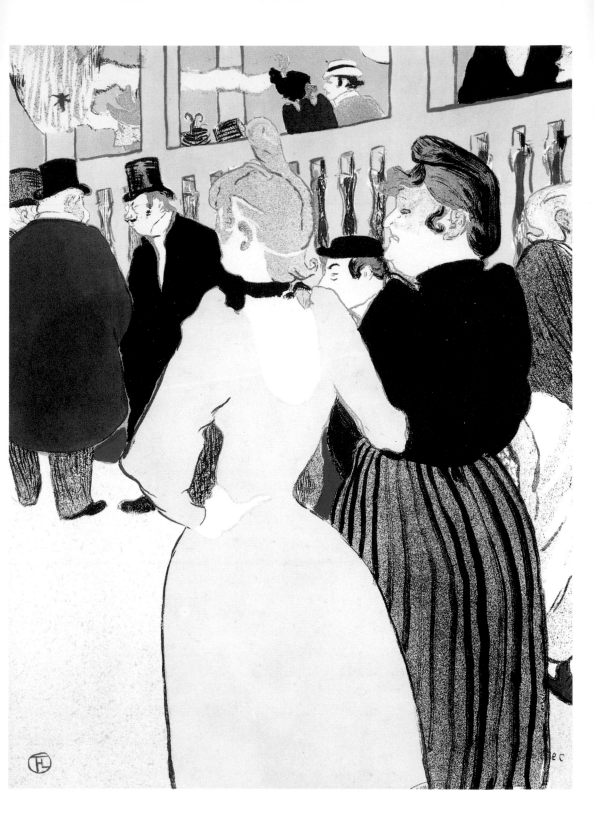

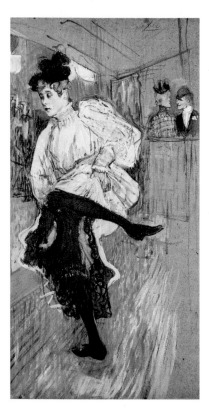

JANE AVRIL, DANSANT, 1892
(Jane Avril, dancing)
oil on cardboard, 33 5/8 × 17 3/4 in.
(85.5 × 45 cm)
Musée d'Orsay, Paris; Dortu P. 416

Facing page:
JANE AVRIL ENTRANT AU MOULIN-ROUGE,
1892
(Jane Avril entering the Moulin-Rouge)
oil and pastel on cardboard,
40 1/8 × 21 5/8 in. (102 × 55 cm)
Courtauld Institute Galleries, London;
Dortu P. 417

thin, kicking legs in their dark stockings. Her facial features are simply presented, fully illuminated and little distorted in significant contrast to the caricatured couple in the background. As it shows the dancer performing, advertising her profession and skill, and employs the devices of Degas', Forain's, and others' paintings of similar themes, this work has Toulouse-Lautrec following a by then standard format in the genre of dance depictions. The other three painted portraits, however, break with this motif of professional representation as they show Jane Avril elegantly dressed to go out. One uses a fairly standard frontal bust portrait composition, remarkable largely in the intense illumination that distorts her facial features and Toulouse-Lautrec's characteristic low point of view, but the other two place her outside the Moulin Rouge, leaving the dance hall or just entering it. Arsène Alexandre, in a 1893 article devoted to Toulouse-Lautrec's representations of Jane Avril, described her as "entering a cafe seemingly totally indifferent to the flattering murmurs ... meditating on the age-old stupidity of men, or on the pretty arrangement of a new outfit."[42] Toulouse-Lautrec maintained the vertical format and painted the image with mixed turpentine-thinned paint and pastel chalks on cardboard, but used a raised perspective unusual for him, enabling us to look down on the figure of Jane Avril as she enters from the night, walking past a hat and coat hung on a stand, her slender figure dressed in a blue coat with fur collar. The lighting — the intermediate illumination as she moves from dark night to bright interior — mutes the red of her hair and renders her facial features pallid as shadows beneath unequally opened eyes and her pursed lips become accented and the raised point of view elongates her face. Distorted in this way, Jane Avril is seen in a moment of quiet contemplation, a privileged view away from her public performance that allows us to witness her private existence or, rather, to re-experience Toulouse-Lautrec's sharing of that privacy as he staged it for us.

Such a private, privileged image and its denial of flattery, its push toward something caricatural, contrasts markedly with the images of Jane Avril conceived by Toulouse-Lautrec for commercial consumption in posters. The first of these placed her in the audience of the

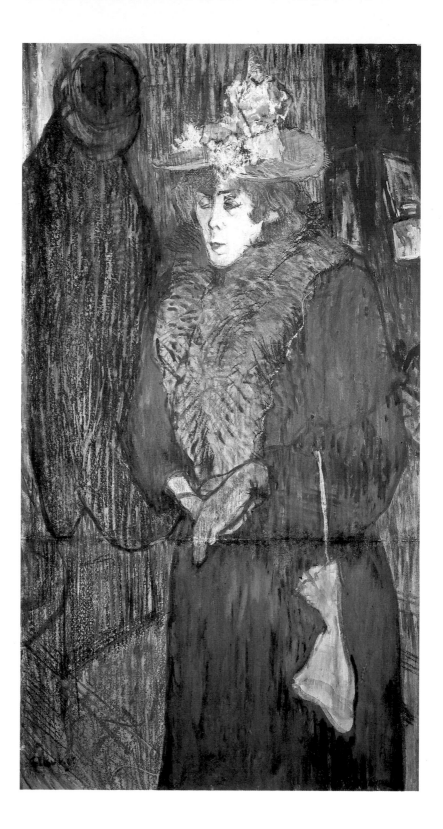

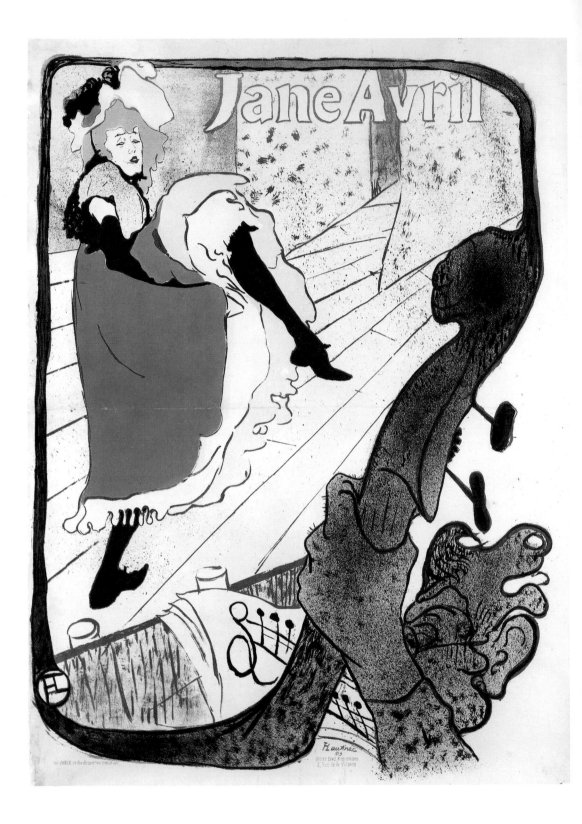

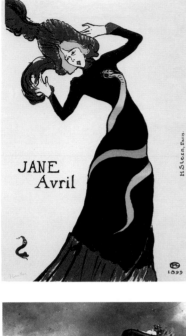

JANE AVRIL, 1899

color lithograph, poster, 21 7/8 × 13 1/2 in.

(55.5 × 34.4 cm); Delteil 367 I

Jane Avril, Photograph, Musée du Vieux
Montmartre, Paris

Facing page:

JANE AVRIL, 1893

color lithograph, poster, 48 3/4 × 36 in.

(124 × 91.5 cm); Delteil 345 I

Divan Japonais *café-concert* (see p. 87), forced to close in December 1892 and then reopened under the new management of Edouard Fournier on 22 January 1893, only to close again on 11 February,[43] "closed again before it ever opened," as Alexandre noted. Jane Avril appears here in the first row of the audience, immediately next to the orchestra pit from which the shadowed forms of the conductor's arms and the necks of contrabasses rise. Placed near her in the audience, we look up at her elegantly clothed, black, silhouetted, slender form, at her ornate English hat, at the precise profile of her face and muted orange of her hair, the focusing spot of color amid the dark tones of the poster. Her detached, focused elegance renders comical the foppish, blond-bearded man nearby — the literary and music critic Edouard Dujardin, cast as a lecherous, wealthy bourgeois type — who squints through his monocle at her while "sucking on the knob of his cane," as Alexandre's suggestive pre-Freudian analysis recognizes.[44]

Jane Avril's fashionable elegance and cool aloofness disappear in the poster she requested that Toulouse-Lautrec prepare for her when she began dancing at the fashionable Jardin de Paris *café-concert* on the Champs-Elysées, which Oller had purchased and for which he provided a special bus line to permit its patrons to go on to the Moulin Rouge with ease. In the large poster, we are positioned to look — much as if we were in a front seat directly behind the orchestra — past the dustily shadowed, satyrlike head of a double-bass player and his hairy hand clasping the instrument's phallically stylized neck, up toward the stage, whose tonality is rendered by the cream of the paper with a few splattered shadows. Jane Avril dances there, her face marked by boredom, her right leg raised, swinging back and forth in time to the music, pendulum-like, emerging from her surrounding white and gold — the color of her hair — petticoats and orange-red dress. A feathered hat and feather boa grant her a kind of tawdry elegance, "nicely dressed in a strange way," according to Alexandre, who compared her to a "frenzied orchid."[45] The floral analogy mixed with perceived neurosis is repeated in other accounts of Jane Avril which also compare her dance to Salome's as she and

Toulouse-Lautrec's images of her take on the archetypical qualities of a hypnotically sensual and beautiful, simultaneously tender and malevolent, *fin-de-siècle* womanhood. The poster, she acknowledged late in life, made her famous; as advertisement it was therefore a success. But Toulouse-Lautrec also privileged it as artwork as he had twenty impressions printed without the intrusive *Jardin de Paris* legend, numbered and signed them, and sold them directly to collectors through the print dealer and publisher Edouard Kleinmann. Commercial product and treasured art object thereby shared their identity. To further sales and consciously market his career as an artist, Toulouse-Lautrec wrote to art critics, asking that they discuss the poster, as Alexandre then did in the aesthetically conservative *Art français*, and arranged for reproductions in other periodicals.

The third of the women of the Moulin Rouge to whom Toulouse-Lautrec devoted his paintings, sketches, and lithographs repeatedly was the *diseuse* Yvette Guilbert, who began performing at the Moulin Rouge in 1890. To his mother he wrote in December 1892 with significant excitement, tempered — or perhaps heightened — by the knowledge that his family would disapprove:

> Yesterday in her dressing room she asked me to make a poster for her. This is the greatest success I could imagine, because she has already been interpreted by the most celebrated and it will be necessary to make something very good. The family will not share my joy, but with you it's different.[46]

He announced thereby acceptance of a challenge to compete with established artists such as Chéret and their prior portrayals of the singer. But he also saw an opportunity for furthering his own career by attaching it to the reputations of both Chéret and Guilbert. Her reputation, built on a repertoire of songs — including Aristide Bruant's — distinctively humorous, ribald, and satirical, mocking and feigning innocence, critically exploring bourgeois vices and indulgence, delivered in an argotesque, scratchy, acid voice that contrasted with her elegant white or green satin gowns and signature long black gloves, closely matched

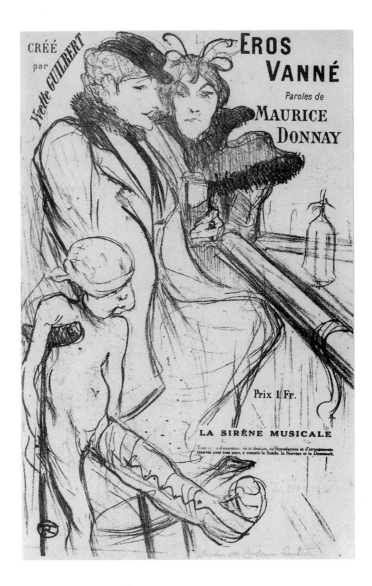

EROS VANNÉ, 1894

(Exhausted Eros)

lithograph, 10 7/8 × 7 1/8 in. (27.5 × 18 cm);

Delteil 74 III

the one Toulouse-Lautrec was carefully crafting for himself. It was an astute, exploitative, and extraordinarily successful marketing strategy.

Despite sketches, no poster came of the 1892 meeting, but Toulouse-Lautrec nonetheless initiated an extended exploration of Yvette Guilbert in drawings, poster designs, and lithographs. He designed covers for the sheet music of her songs, such as "Eros vanné," an ironic presentation on lesbian love, and repeatedly pub-

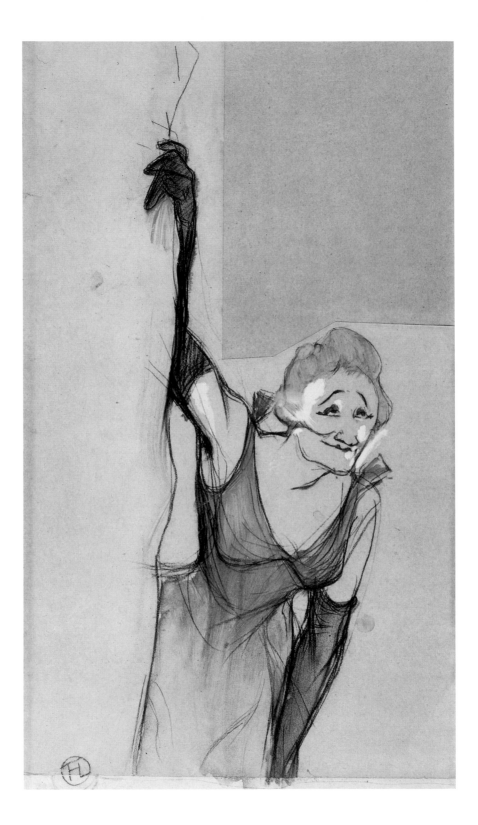

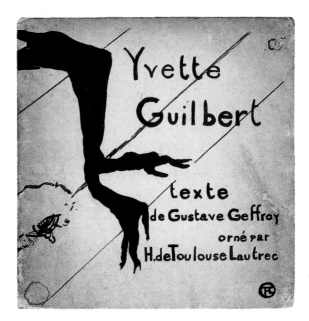

lished drawings of her in performance as illustrations for magazine articles on the pleasures of Paris or the varieties of the *café-concert*. She also became the focus in 1894 of a series of sixteen lithographs collected into an album limited to a hundred impressions, with text written by the critic and anarchist sympathizer Gustave Geffroy and published by the recently founded *L'Estampe originale,* which sought to further quality printmaking in France.

Much as Yvette Guilbert's career brought her from the bohemian and lower-class cafés of Montmartre to luxurious music halls on the Champs-Elysées, Toulouse-Lautrec's similarly underwent dramatic transformations during the early 1890s as he moved from marginal sites for the presentation of his art to the public — anti-bourgeois periodicals, dance hall and cabaret foyers — to the refined venues of avant-garde group exhibitions in Paris and Brussels and art galleries. Most significant became the fashionable art gallery of Goupil-Boussod et Valadon, of which Maurice Joyant, a friend of Toulouse-Lautrec since they both had attended the Lycée Fontanes in 1872–74, became director in September 1890 when Theo van Gogh became too ill to continue working there. Almost immediately, Joyant set out to market Toulouse-Lautrec's works;

Couverture de l'Album Yvette Guilbert, 1894
(Cover for the Album Yvette Guilbert)
transfer lithograph, 15 1/8 × 16 1/8 in.
(38.3 × 41 cm); Delteil 79

Facing page:
Yvette Guilbert saluant le public, 1894
(Yvette Guilbert Greeting the Audience)
chalkpen, watercolor, and oil on tracing paper, stretched on cardboard, 16 3/8 × 9 in.
(41.6 × 22.8 cm)
Museum of Art, Rhode Island School of Design, Gift of Mrs. Murray S. Danforth

Charles Maurin
et Henri de Toulouse Lautrec
ont l'honneur de vous
inviter à visiter quelques-
unes de leurs œuvres
exposées chez
MM. Boussod et Valadon

19 Boulevard Montmartre du Lundi 30
Janvier au Samedi 11 Février

Photograph of Maurice Joyant

Invitation for the opening of the exhibition at
the Galerie Boussod & Valadon, 1893

Facing page:
Divan Japonais, 1892–93
color lithograph, poster, 31 3/4 × 23 7/8 in.
(80.8 × 60.8 cm); Delteil 341

in 1891 and 1892, he bought and sold several paintings through the gallery. Moreover, it seems more than likely that Toulouse-Lautrec's very rapid, quite remarkable rise in critical esteem and attention as of late 1891, when Alexandre wrote his review, had Joyant as one of its intermediaries. Because of his prior work with *Paris Illustré* as well as his gallery directorship, Joyant was well acquainted with Paris' major art critics and interacted with them regularly, influencing their choice of work to discuss. It is unlikely, I believe, that he would have failed to promote his childhood friend among them.

That much remains conjecture. What is certain is that between 30 January and 11 February 1893, Joyant sponsored Toulouse-Lautrec's first gallery exhibition at Boussod-Valadon, linking it — according to Joyant, at Toulouse-Lautrec's own request — with an exhibition of works by Charles Maurin, known as an innovative print-maker but also an active anarchist who engraved a highly popular portrait of Ravachol. Despite his new-found acceptance in the circles of high art, it seems, Toulouse-Lautrec wished to retain links with radical ideological positions even if he refused to espouse them openly. Exhibited were about thirty paintings, pastels, posters, and lithographs. This exhibition also marked the full absorption into the contemporary art establishment that was the necessary goal of Toulouse-Lautrec's tactics of self-advertisement, his search for motifs and subjects that had currency, providing him and his work with a readily recognizable profile. The exhibition represented a fulfilled retreat from radicalism. This road to bourgeois acceptance, moreover, mirrored the similar process Montmartre's music halls and their performers generally underwent during the years after 1890. Montmartre retreated from itself while Toulouse-Lautrec began to withdraw from Montmartre.

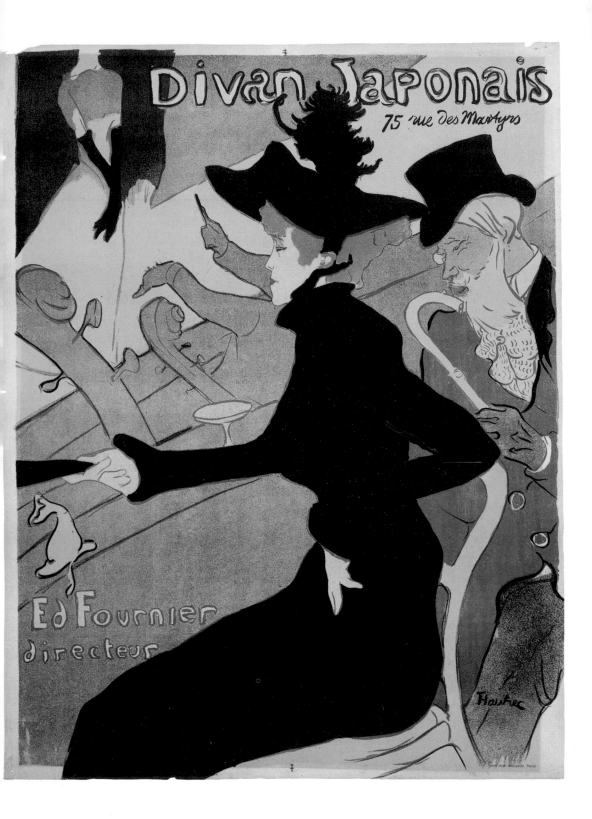

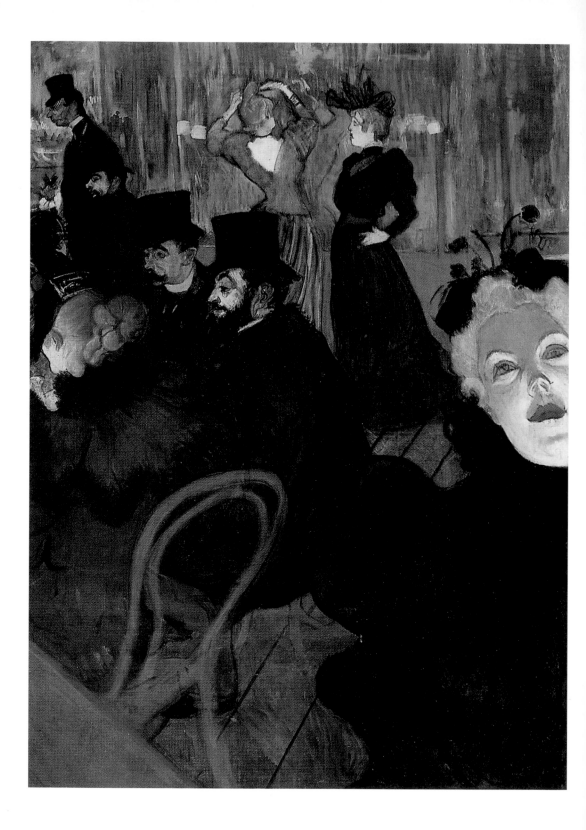

Au Moulin Rouge was cut apart and put back together again, that much is certain. The garish figure of May Milton was divorced from the group around the table, which was made into a separate image and apparently exhibited that way at the Salon des Indépendants in 1902, shortly after Toulouse-Lautrec's death (see p. 90). It was put back together again sometime around 1914. But in the process of separation and reunification, a small strip of canvas was lost, and the two parts therefore no longer match properly. Portions of May Milton's hat, collar, and sleeve also shifted, as did Jane Avril's chair and the balustrade; formerly continuous brush strokes were cut, and threads no longer run unbroken across the width of the canvas.[47] The perpetrators of this bizarre vandalism and of its flawed correction with slightly misaligned parts can only have been the art dealers who owned the painting after 1902, the Parisian gallery of Manzi-Joyant. For Maurice Joyant, it appears, the target was the large, dominating figure of May Milton.

Joyant, ironically, is our major source for information about her.[48] Toulouse-Lautrec, who became aware of her in 1894, quickly produced a confluence of images that featured her, including a portrait in thinned oils and pastels on cardboard (see p. 92) and a lithograph poster for her planned American tour in 1895. He introduced her on the cover of the song sheet "Eros vanné," using her characteristic hat with its two feathered antennae as well as her elongated face that, according to Joyant, was "clown-like and reminded one of nothing so much as a bulldog."[49]

A sense of frozen time, of motion stopped, and of a vague unreality characterizes the scene of Au Moulin Rouge. Women and men, all friends, sit or stand or saunter silently, without communication or focus, in isolation one from the other. Alienation and ennui appear to frame their existence. This may be the result of Toulouse-Lautrec having composed the scene from various prior portraits of the women and men which he then combined into a pastiche. But it may also be that what we see is no con-

AU MOULIN ROUGE, 1894–95,
(At the Moulin Rouge), reconstruction

Facing page: detail

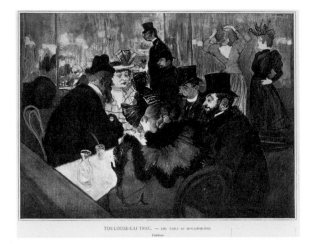

TOULOUSE-LAUTREC. — UNE TABLE AU MOULIN-ROUGE
Tableau

temporary scene, but a picture of unchanging memories from a time trapped in the past.

What Toulouse-Lautrec painted in 1895 no longer existed. The dancers were no longer employed by the Moulin Rouge, and the men with them no longer frequented the Moulin Rouge. The Moulin Rouge too had changed. Zidler had resigned as director of the dance hall in 1892 "for health reasons," and Oller had appointed his brother, Jean, as a replacement. The most well-known dancers — Jane Avril, La Goulue, and others — had moved on to other dance halls or took their acts on tour. The *quadrille naturaliste* and the cancan themselves ceased to be major attractions and were largely replaced after 1894 by staged revues, operettas, comedy acts, *tableaux vivants*, bicycle races, and other variety programs. Toulouse-Lautrec painted a recollection of what only recently had been, of friendships and public places that had ceased to be.

Although it is one of his largest paintings, on canvas rather than cardboard, Toulouse-Lautrec never exhibited *Au Moulin Rouge*; unlike other paintings he showed during his lifetime, it is not signed by him. Its function was private, not public. As such, it acted as a personal complement to the two paintings La Goulue commissioned from him in April 1895 to decorate her booth at the fairgrounds of the Foire du Trône. La Goulue

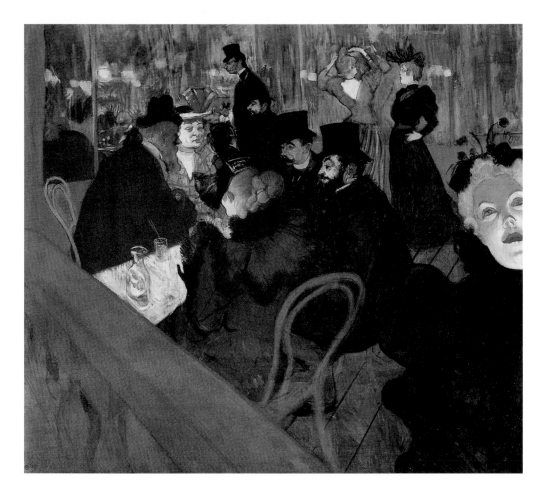

Au Moulin Rouge, 1894–95
(At the Moulin Rouge)
oil on canvas, 48 3/8 × 55 1/2 in.
(123 × 141 cm)
The Art Institute of Chicago, Helen Birch
Bartlett Memorial Collection; Dortu P. 427

provided the canvas as Toulouse-Lautrec had been painting solely on cardboard — a support far from suitable for outdoor display — since 1892. One panel showed the *quadrille* being danced by La Goulue and Valentin le Désossé, a scene from the dancer's past, more drawn in color than painted and with most of the canvas left bare, a neutral space of memory in which the dance is performed. The other panel offered an imagined present in which La Goulue performed her "Moorish dance" for an audience of her former Moulin Rouge friends, a mingling of past and present in which gently caricatured figures of Paul Sescau, Maurice Guibert, Gabriel Tapié de Céleyran, Oscar Wilde, Jane Avril, Toulouse-Lautrec himself, and Félix Fénéon gazed up at her performance. *Au Moulin Rouge*, with several of the same participants, is a more

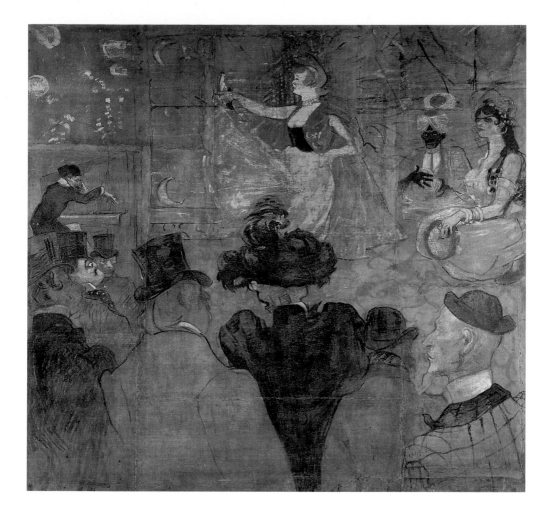

BARAQUE DE LA GOULUE A LA FOIRE DU
TRÔNE: LA DANSE MAURESQUE, 1895
(La Goulue's Booth at the Foire du Trône:
Moorish Dance)
oil on canvas, 11 1/4 × 11 7/8 in.
(28.5 × 30 cm)
Musée d'Orsay, Paris; Dortu P. 591

Facing page:
MAY MILTON, 1895
oil and pastel on cardboard,
26 × 19 3/8 in. (65.9 × 49.2 cm)
The Art Institute of Chicago, Bequest of
Mrs. Kate L. Brewster; Dortu P. 572

contemplative, careful recollection, not of a performance,
but of silent times between performances, times of shared
company and drinking rather than of dance and sexual
innuendo.

In *Au Moulin Rouge*, Toulouse-Lautrec turned
inward, away from the public entertainments of Mont-
martre which often dominate his paintings and posters.
It is an ironic turning inward, however, a turning inward
to a public scene, not a private moment, as if that public
presence with its companionship and alcohol were a
necessary mask of further memory. During the time from
shortly before his 1893 Boussod-Valadon exhibition to
1895, Toulouse-Lautrec himself undertook an analogous

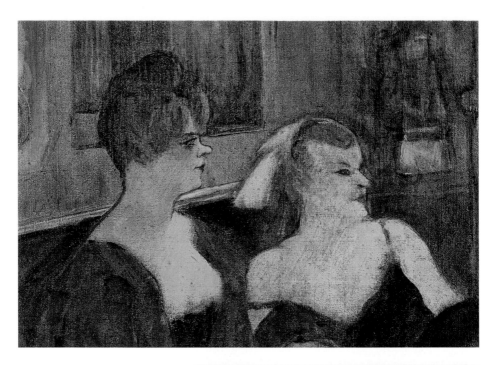

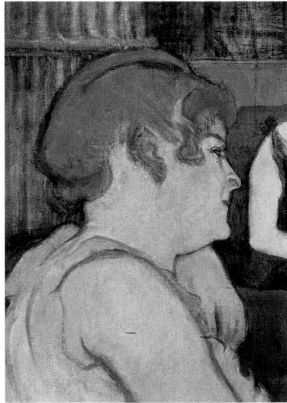

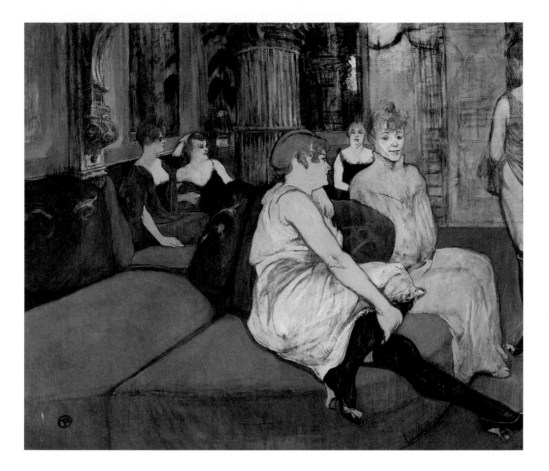

Au salon de la rue des Moulins, c. 1894
(At the Salon in the rue des Moulins)
black chalk and oil on canvas,
45 $^1/_2$ × 52 $^1/_8$ in. (115.5 × 132.5 cm)
Musée Toulouse-Lautrec, Albi; Dortu P. 559

Facing page:
Au salon de la rue des Moulins, details

withdrawal into a public privacy as he became a frequent visitor in fashionable brothels, such as the one at 6 rue des Moulins. This was a stylish public house, grandiosely furnished, with rooms decorated in Moorish, Chinese, Gothic, Baroque, and other historicist or exotic styles, catering to middle- and upper-class patrons. As he had done with the Moulin Rouge, Toulouse-Lautrec used the setting of the brothel for a series of works during the next three years. Commentators and friends have conjectured that the deformed artist could escape only here, through the commercial love of prostitutes, the disdain, revulsion, and cruelty other women habitually showed toward him. Whether or not that is a correct analysis, other issues must be factored in, including the emulation of admired artists who painted images of prostitution and the interiors of *maisons closes*, and the noted Naturalist novels by Zola,

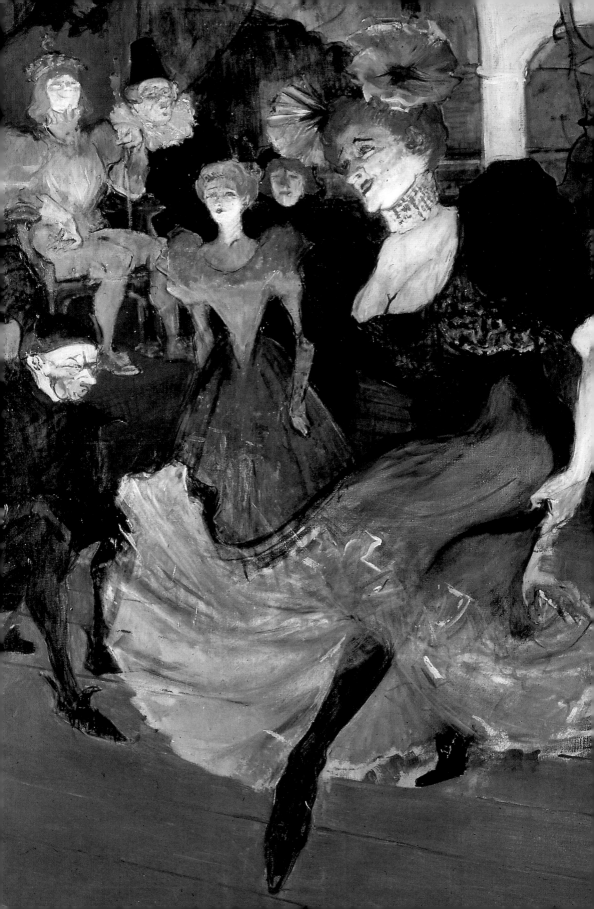

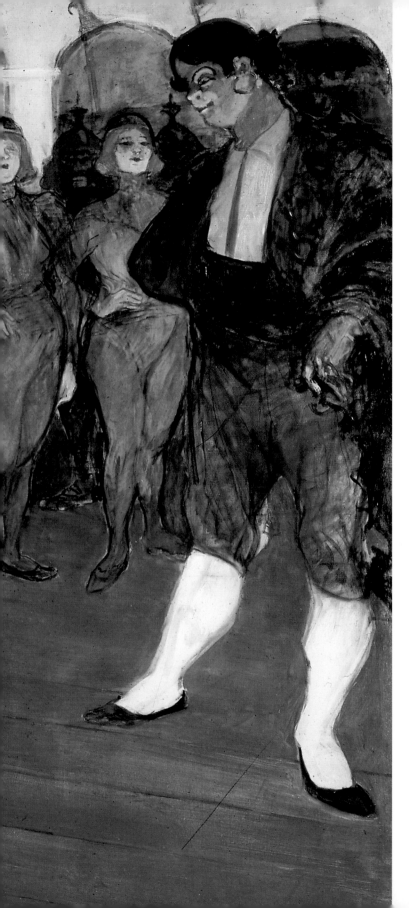

CHILPÉRIC (MLLE.
MARCELLE LENDER
DANSANT LE PAS DU
BOLERO), 1896
(Chilpéric: Mlle. Marcelle
Lender dancing the Bolero)
oil on canvas, 60 5/8 × 59
in. (154 × 150 cm)
Whitney Museum of
American Art, New York;
Dortu P. 627

Huysmans, and the Goncourts on themes of prostitution. Even taking these and contemporary debates about prostitution in France into account, it remains impossible to determine why Toulouse-Lautrec engaged in his extensive personal depiction of brothel life, however.

As in his dance hall paintings, Toulouse-Lautrec only rarely sought out the public functions of the women and their house. Titillating voyeuristic scenes of interaction with customers appear in caricatures by him, probably made for his own and his male friends' personal amusement, but seldom in paintings, although it is possible that the more scabrous images by him were destroyed by his family or altered, as when the accompanying man was cut from the small scene of a partially naked prostitute crawling up a staircase. What he sought out instead were private moments, domestic scenes that are privileged in that they would not be seen by most of the women's visitors. In these, the women are among themselves, helping each other arrange their toilettes, simply sitting together among the extravagant furnishings of their salon (see pp. 94–95), or standing in a row to await their state-mandated medical examination for venereal disease. While the precise meanings of these images is difficult to discern, they become an aestheticised catalogue of ironically desexualized life in a brothel, with Toulouse-Lautrec's habitually caricatured faces and bodies functioning perhaps as moral or ideological commentary, the physical appearance of painting and figure surely countering the expectations of the common audience for images of prostitution. "It is the pitiless, horrible haunts of prostitution, these toilets of love, into which Lautrec enters," wrote the German critic Erich Klossowski in 1903. "Here there is nothing tempting, nothing that arouses."[50]

Among the paintings of the *maisons closes*, one group is distinct as it concerns scenes of prostitutes embracing, kissing, sleeping together, or enjoying the proximity of each others' bodies. The images tend to be relatively naturalistic, tending less toward caricature than the majority of the brothel paintings. Toulouse-Lautrec exhibited several of these scenes of lesbian affection and sold

Deux femmes demi-nues de dos, 1894
(Two women, semi-nude, rear view)
oil on cardboard, 21 $^1/_4$ × 15 $^3/_8$ in.
(54 × 39 cm)
Musée Toulouse-Lautrec, Albi; Dortu P. 556

Facing page:
La femme tatouée, c. 1894
(Tattooed Woman)
oil on cardboard, 24 $^5/_8$ × 18 $^7/_8$ in.
(62.5 × 48 cm)
Sammlung Hahnloser, Bern; Dortu P. 551

or gave several to male friends. Whatever else the paintings may reveal, they point to a fascination with lesbian couples on the part of the artist and his circle, but also a readiness for their display in art exhibitions, a type of social acceptance. This has, I believe, significant bearing on *Au Moulin Rouge* and its fate in so far as May Milton was involved in at least one lesbian relationship, with Jane Avril. She appears therefore on the cover of "Eros vanné," the melancholic-sarcastic song sung by Yvette Guilbert about an Eros "born on a bed of tarnished roses," the exhausted intermediary in the love of two women for each other. The association of May Milton with lesbian love in this fashion may underlie her removal from the painting in an effort to purify it of "perverse" references.

Toulouse-Lautrec inaugurated the purification and de-demonization of his art in the process of withdrawal from Montmartre and its ideologies. After 1895, after *Au Moulin Rouge*, the butte and its inhabitants play

DANS LE LIT, 1892

(In Bed)

oil on cardboard, 25 $^1/_4$ × 23 $^1/_4$ in.

(64 × 59 cm)

Musée d'Orsay, Paris; Dortu P. 439

only minor roles in his work. Marketed by Joyant, celebrated above all for his lithographs, he withdrew from significantly controversial subjects, translated them into more neutral formulations, or accented technical refinements in their presentation.

The situation of the *quadrille*, but not the dance itself, therefore appears in *Chilpéric*, 1896 (see pp. 96–97), where it is the staging of an operetta that we see as the actress sings and dances, surrounded by a costumed entourage. The unpredictability of the *quadrille naturaliste*, its anarchist linkage and its argot performance, are replaced by the intensity of theatrical effect. Control dominates. Similarly, the portfolio of eleven lithographs entitled *Elles* (see p. 103) offers dissociated scenes of women, at least some of them prostitutes, as they wash and groom themselves, dress or undress before men, or recline partially clothed on their beds. The motifs here are familiar ones, drawn from the repertoire of Naturalist art, and remarkably delicately rendered. Each print, moreover, concentrates on

L'Abandon: Les Deux Amies, 1895
(Devotion: The Two Girlfriends)
oil on cardboard, slit on left side,
17 7/8 × 26 3/8 in. (45.5 × 67.5 cm)
Private collection; Dortu P. 598

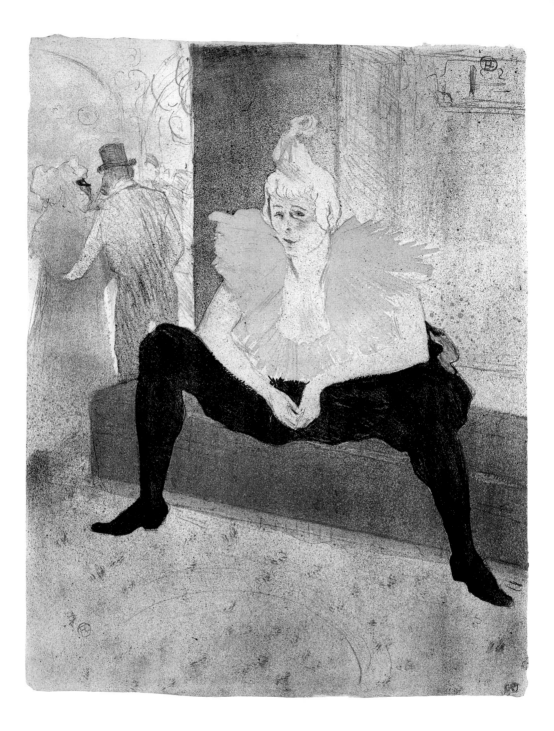

different aspects and variations of lithographic technique, so that the portfolio emerges as a demonstration of technical abilities and invention.

The anti-art radicality, social critique, and linkage to anarchism disappeared, to be replaced by more traditional, tried and tasteful approaches. When May Milton was removed from *Au Moulin Rouge*, the same transformation was accomplished. Her garishly lit face, her green- and yellow-tinted skin, her masklike stare broke the naturalistic unity of the painting. Without her figure, the painting became a common café genre scene set in the Moulin Rouge and lent anecdotal color by that setting. It was the defensive act of Joyant, it would appear, that was designed to refine, purify, and render critically acceptable the work in which Toulouse-Lautrec contained the memory of a different Moulin Rouge.

FRONTISPICE POUR *ELLES*, 1896
(Frontispiece for the portfolio *Elles*)
color lithograph, 20 5/8 × 15 7/8 in.
(52.4 × 40.4 cm)
The Museum of Modern Art, New York,
Bequest of Abby Aldrich Rockefeller;
Delteil 179

Facing page:
LA CLOWNESSE ASSISE, MADEMOISELLE
CHA-U-KA-O, 1896
(Seated Clown, Mademoiselle Cha-u-ka-o)
color lithograph, plate I of the series *Elles*,
20 3/4 × 16 in. (52.7 × 40.5 cm)
The Museum of Modern Art, New York,
Bequest of Abby Aldrich Rockefeller;
Delteil 180

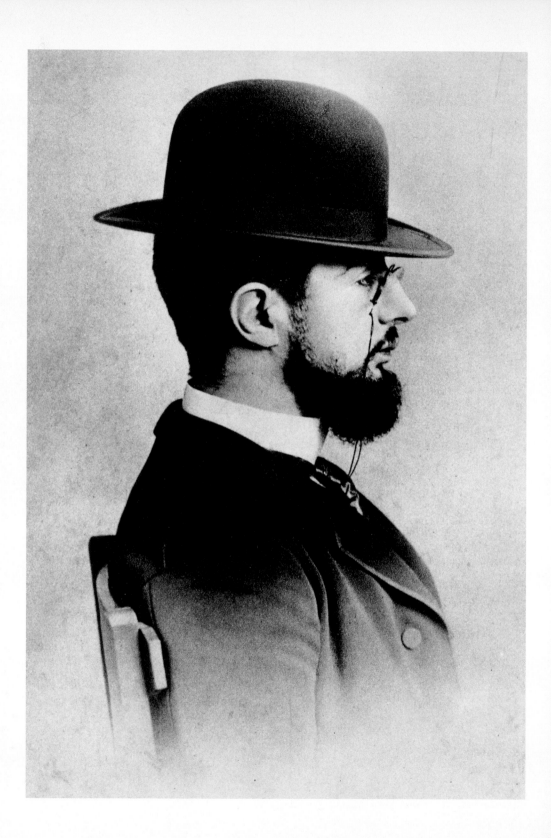

1864

Henri-Marie-Raymond de Toulouse-Lautrec Montfa is born at six o'clock in the morning on 24 November at the Hôtel du Bosc, Albi. He is the first child and oldest son of Alphonse-Charles-Jean-Marie, Count of Toulouse-Lautrec Montfa (1838–1913), and Marie-Marquette-Adèle-Zoë-Tapié de Céleyran (1841–1930). The parents were first cousins. The house of Toulouse traces its ancestry back to the eighth century.

1867

His brother Richard-Constantine is born on 28 August; he dies within a year on 27 August 1868.

1870

In July, the Franco-Prussian War begins. Napoleon III is captured after the Battle of Sedan. On 4 September, the Republic is proclaimed in Paris.

1871

In March, the Paris Commune is established. In May, republican troops suppress the Commune. The Treaty of Frankfurt formally ends the Franco-Prussian War.

1872

The family moves to Paris in the autumn. Toulouse-Lautrec is enrolled at the Lycée Fontanes (today the Lycée Condorcet).

1875

Toulouse-Lautrec aged 3

Facing page: Toulouse-Lautrec aged *c.* 25

Has general health problems, notably difficulties with his weak-boned legs (believed to be due to osteogenesis imperfecta or pyknodysostosis) that force him to leave the

Lycée Fontanes. Boarded with M. Vernier in Neuilly, receives treatment for his condition and draws and paints watercolors.

1876

Passes his lycée examinations on 11 May, and on 12 June celebrates his first communion.

1878

In Albi in May (before 22 May), slips while getting up out of a low chair and breaks his left femur. During his year-long convalescence, paints watercolors and first oils under the tutelage of the *peintre sportif* René Princeteau.

1879

In August, after a trip to the Marian shrine at Lourdes, at Barèges, while on a walk with his mother, falls into a ditch and breaks his right leg. Thereafter, neither leg continues to grow, and both remain short, crippled, and exceedingly brittle. Although his torso attains normal size, due to the stunted growth of his legs, he will only reach a height of about five feet.

1881

In April, leaves for Paris to study painting with Princeteau. Rodolphe Salis opens the Cabaret du Chat Noir on Montmartre and begins publishing the journal *Le Chat noir*.

1882

On 17 April, enrolls at Léon Bonnat's studio, then in the fall joins the studio of Fernand Cormon, with whom he studies until 1887. Fellow students during this time include Louis Anquetin, Emile Bernard, Vincent van Gogh, and François Gauzi.

1883

At the Société des Amis des Arts in Pau, exhibits a paint-

With his uncle, Charles (left), and father (right) at the Château du Bosc, *c.* 1877

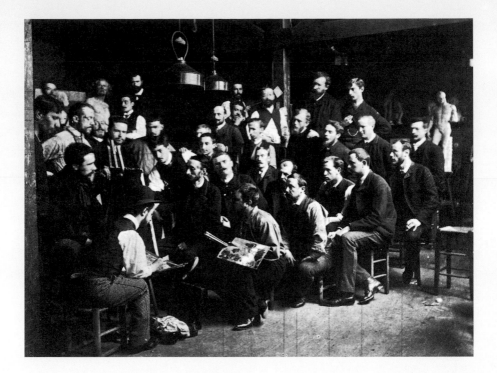

ing publicly for the first time. In May, his mother purchases the estate of Malromé (Gironde). During the summer, begins to depict agricultural workers at the family estate at Céleyran.

1884

In spring, his health exempts him from military service. Moves into rooms shared with Albert Grenier in Paris at 19*bis* rue Fontaine. Cormon invites him to participate in a project to illustrate the national edition of Victor Hugo's works.

In Paris, the Société des Artistes Indépendants is founded and organizes its first exhibition. In Brussels, the avant-garde exhibition society Les XX is founded.

1885

Begins to frequent the cabarets in Montmartre and becomes acquainted with Aristide Bruant. His work

Fernand Cormon's studio. Toulouse-Lautrec is seated at the front left, *c*. 1885

begins to display the influence of the urban motifs and stylistic practices of radical Naturalism and Impressionism.

On 10 June, the Cabaret du Chat Noir moves from the boulevard Rochechouart to the rue de Laval. Bruant leases the vacated space and opens his cabaret Le Mirliton there.

1886

Despite Cormon's rejection of stylistically radical innovations in his, Anquetin's, and Bernard's paintings, continues to work in the Academician's studio. Rents a studio on Montmartre, and his paintings and drawings begin to focus on motifs from the world of popular entertainment, as well as on social themes often derived from Bruant's songs. His drawing *Gin-cocktail* is published in the 26 September issue of the popular journal *Le Courrier français*. Under the pseudonym of "Tolav-Segroeg, Hungarian of Montmartre," participates in the parodic Salon des Artistes Incohérents. In December, Bruant places paintings by Toulouse-Lautrec on "permanent display" at Le Mirliton and publishes his *Quadrille de la chaise Louis XIII à l'Elysée Montmartre* on the cover of *Le Mirliton*.

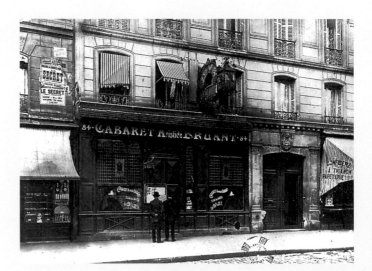

Montmartre, in the foreground the cabaret Nouvelles-Athène, *c.* 1906

The cabaret of the chansonnier Aristide Bruant

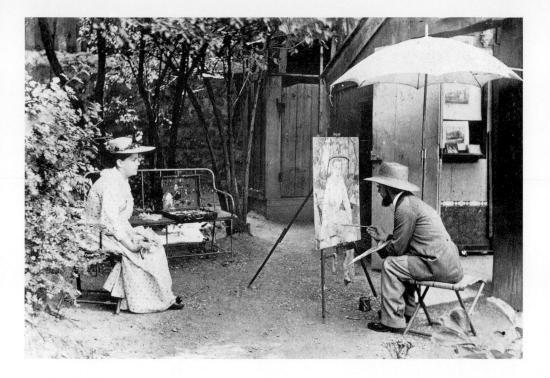

1887

Leaves Cormon's studio. His drawings on motifs of Bruant's songs continue to appear in *Le Mirliton*. With Anquetin, Bernard, and Van Gogh, exhibits paintings at Grand Bouillon, Restaurant du Chalet, 43 avenue de Clichy, Montmartre. Invited to exhibit his work with Les XX.

Painting out-of-doors, in Monsieur Forest's garden, 1890

Billboard with Toulouse-Lautrec's poster advertising Aristide Bruant's cabaret

After the resignation of Jules Grévy, Sadi Carnot is elected president of the French Republic.

1888

Exhibits eleven works at the Les XX exhibition in Brussels and publishes drawings in *Paris illustré*.

The Boulangist movement reaches its height in France.

1889

Exhibits three works, including *Le Bal du Moulin de la Galette*, at the Salon de la Societé des Artistes Indépendants, and his paintings are featured in the foyer of the newly opened Moulin Rouge dance hall on Montmartre.

The Exposition Universelle takes place in Paris. On 6 October, Joseph Oller and Charles Zidler open the Moulin Rouge dance hall on the place Blanche of Montmartre.

1890

Exhibits with Les XX and the Salon des Artistes Indépendants.

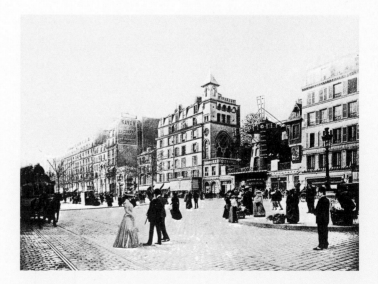

Louis Anquetin and
Toulouse-Lautrec with
a hunting dog, *c*. 1885

Place Blanche with a view
of the Moulin Rouge (right)

1891

Exhibits at the Cercle Volney, the Salon des Indépendants, the Salon des Arts Libéraux, and in the Exposition des Peintres Impressionistes et Symbolistes at the Barc de Boutteville gallery. Sues Jules Rocques of *Le Courrier français* for attempting to sell unpublished and unpaid-for drawings. Charles Zidler of the Moulin Rouge commissions him to produce a poster for the dance hall.

In October, the Natanson brothers found the Revue blanche.

1892

Exhibits paintings and multiple states of his Moulin Rouge poster at Les XX and the Salon des Artistes Indépendants. In January, the first extensive critical evaluation of his work, Arsène Alexandre's "Chronique d'aujourd'hui: Henri de Toulouse-Toulouse-Lautrec," appears in the republican newspaper *Le Paris*. Takes part in the artists' masquerade Bal des Quat'z Arts at the Elysée Montmartre. In May–June, visits London. Posters become a major aspect of his work and are exhibited by him with his paintings.

The anarchist terrorist François-Claudius Ravachol is arrested and executed after setting off several bombs in Paris. The period of anarchist "propaganda by the deed" extends through 1894.

The dancer and acrobat Cha-u-Ka-o
Photograph by Maurice Guibert

1893

During this year, produces a total of forty-five lithographs. He exhibits paintings, lithographs, and posters at Les XX, the Salon des Artistes Indépendants, Le Barc de Boutteville, the Société des Peintres-Graveurs Français, and with the Association pour l'Art in Antwerp. In January, a two-artist exhibition devoted to works by him and by Charles Maurin opens at the Boussod-Valadon gallery managed by Maurice Joyant. The first issue of *L'Estampe originale* features a lithograph by Toulouse-Lautrec as its cover. In April, he accompanies Aristide Bruant on a trip to Normandy. In November, a special issue of *La Plume* devoted to posters includes Frantz Jourdain's "L'Affiche moderne et Henri de Toulouse-Lautrec." *L'Estampe originale* publishes *Le Café-Concert*, an album of twenty-two lithographs by Toulouse-Lautrec and Henri-Gabriel Ibels. *Figaro illustré*, *L'Art français*, *L'Escarmouche*, and *La Plume* feature illustrations by him.

On 9 December, the anarchist Auguste Vaillant tosses a bomb into the Chamber of Deputies.

Toulouse-Lautrec painting *Dressage des Nouvelles, par Valentin le Désossé* in his studio, c. 1889/90

Facing page:
Tremolado and Toulouse-Lautrec looking at Jules Chéret's poster *Moulin Rouge*, 1892

Toulouse-Lautrec aged 30

1894

In conjunction with exhibitions of his lithographs and
paintings, travels to Holland, Belgium, and England. In
London, meets James McNeill Whistler and Oscar Wilde.
In Paris, exhibits at the Salon des Artistes Indépendants,
in the seventh Exposition des Peintres Impressionistes et
Symbolistes at the Barc de Boutteville gallery, and at the
third *Salon des Cent* at the gallery of the periodical *La
Plume*. The Durand-Ruel gallery has an exhibition de-
voted to his lithographs. Publishes the album of sixteen
lithographs devoted to Yvette Guilbert in an edition of a
hundred impressions. At the Bal des Quat'z Arts, wears
the costume of an altar boy. Spends the summer with his
mother at Malromé and takes a sailing trip to Spain.

*Beginning in January, the new lois scélérates authorize an
extensive campaign of repression and arrests directed
against anarchists and their publications. Vaillant is exe-
cuted. On 12 February, Emile Henry sets off a bomb at the
Café Terminus. On 24 June, President Sadi Carnot is
assassinated by the Italian anarchist Santo Jeronimo
Caserio in Lyons. In August at the Procès des Trente, thirty*

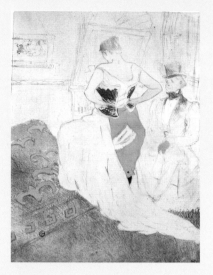

writes and others are accused, then acquitted of anarchist conspiracy. On 22 December, the court martial of Capt. Alfred Dreyfus ends when he is sentenced for espionage.

1895

Thadée and Misia Natanson of *La Revue blanche* befriend Toulouse-Lautrec. *L'Estampe et l'affiche* sponsors publication of *La Lithographie originale en couleurs* with a chapter devoted to him. Designs the sets for Victor Barrucand's play *Le Chariot de terre cuite* at the Théâtre de l'Oeuvre. Exhibits lithographs at La Libre Esthétique in Brussels, and in Paris at the eleventh Salon des Artistes Indépendants and at the Lafitte gallery, while his work is also featured at the exhibition devoted to the centenary of lithography at the Ecole des Beaux-Arts. The dealer Ambrose Vollard begins to serve as agent for his paintings and prints and is instrumental in the publication of his lithograph portrait of the singer-dancer Marcelle Lender in the progressive German periodical *Pan*. The dancer La Goulue commissions him to paint the decorations of her booth at the Foire du Trône. With Maurice Guibert, takes a sailing trip to Spain. Works on a number of large paintings on canvas, including *Au Moulin Rouge*.

1896

An exhibition devoted to Toulouse-Lautrec's works is featured at the Manzi-Joyant gallery. His posters and

Woman in Corset (Passing Conquest), from the portfolio *Elles*, color lithograph, 1896

La Chaîne Simpson, poster, 1896

Toulouse-Lautrec painting Toulouse-Lautrec,
photomontage by Maurice Guibert, 1890

lithographs are included in exhibitions at La Libre
Esthétique in Brussels, in the *Exposition d'Affiches Artis-
tiques, Françaises et Etrangères, Modernes et Retro-
spectives* in Paris, and in London. Due to his interest in
cycling, visits London for the Simpson Bicycle Chain firm
and produces a poster for it. Takes additional trips to Nor-
mandy, the Loire Valley, and Spain.

1897

During the exhibition of La Libre Esthetique in Brussels,
visits the Art Nouveau architect and designer Henry van
de Velde. At the Salon des Artistes Indépendants and the
Société des Peintres-Graveurs, displays lithographs from
the new portfolio *Elles*. Takes trips to Holland and to Lon-
don. Frequents the home of the Natansons and associates
with other artists supported by them and the *Revue*

blanche. In his correspondence, begins to complain of lethargy and an inability to work or to find new ideas for his art.

1898

Moves into a new studio on the avenue Frochot and is said to leave behind over eighty works in his prior studio. At his studio, arranges a private showing of works selected to be exhibited at the Gallery Goupil in London. Accompanies the exhibition to London, where the publisher W. H. B. Sands had printed his series of thirteen lithographs depicting noted actors and actresses as well as the lithographic album *Yvette Guilbert — On Stage*. During the year, begins to receive regular medical treatment for the effects of alcohol poisoning.

1899

After his mother leaves Paris in January, his mental and physical health declines markedly. In late February or

Invitation: invitation to the opening of his new studio in the avenue Frochat, 1897

Toulouse-Lautrec and La Goulue (right) at the Moulin Rouge with some friends

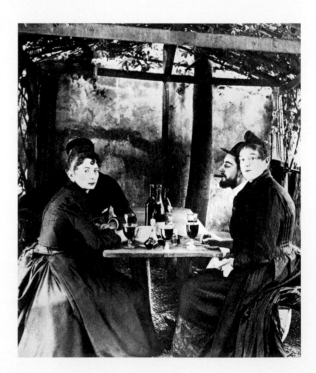

early March, enters the clinic of Dr. Sémelaigne in Neuilly for detoxification until late May. While in the clinic, after a period of inactivity, begins work on a series of drawings of circus motifs. Goes to Albi for further recuperation, then travels to Le Havre and the Atlantic coast before returning to Paris, where he relapses into his previous drinking habits. Jules Renard's *Histoires naturelles* is published with illustrations by him.

1900

Exhibits in Paris at the Exposition Universelle Centennale et Décennale de la Lithographie and in his own studio, as well as at the exhibition of modern art in Bordeaux. After a trip along the French coast of the English Channel, arrives at Malromé in October and then moves to Bordeaux. His health continues to decline.

Toulouse-Lautrec with his mother in the garden of her estate at Malromé, *c.* 1900

1901

In Bordeaux, visits the theater regularly and completes six paintings of scenes from the musical drama *Messalina* by Armand Silvestre and Eugène Morand. In April, leaves for Paris to put his studio in order, remaining until mid-July. A portrait by him is included in the third exhibition of the Berlin Secession. Returns to southern France, to the resort of Taussat, where he suffers a stroke on 15 August that leaves him partially paralyzed. Toulouse-Lautrec is moved to his mother's estate at Malromé on 25 August and dies there on 9 September in the presence of his parents and his cousin Gabriel Tapié de Céleyran.

Photograph of Toulouse-Lautrec, *c.* 1896

Notes

Unless otherwise noted, translations from the French have been provided by the author.

1 Maurice Joyant, *Henri de Toulouse-Lautrec 1864–1901* (Paris, 1926-27), I, 138–39.

2 On the cutting of the canvas and its reassembly, see my „Rediscovering Henri de Toulouse-Lautrec's *At the Moulin Rouge*," *Museum Studies*, no. 12 (1986), 114–35. Arguments against these conclusions are suggested by Richard Thomson, in *Toulouse-Lautrec*, ed. Richard Thomson, (New Haven and London, 1991), 266–68.

3 Gerstle Mack, *Toulouse-Lautrec* (New York, 1938 [1966]), 24.

4 Countess Attems (Mary Tapié de Céleyran), *Notre Oncle Lautrec* (Geneva, 1963), 56.

5 Letter to an unknown correspondent, *c.* June 1878, in Henri de Toulouse-Lautrec, *Correspondance*, ed. Herbert D. Schimmel (Paris, 1992), no. 29, 56.

6 Letter to Charles de Toulouse-Lautrec, May 1881, in *Correspondance*, no. 59, 84.

7 The most thorough discussion and systematic clarification of Toulouse-Lautrec's Academic training and studies, as well as the initial post-Academic works, is Gale B. Murray, *Toulouse-Lautrec: The Formative Years 1878–1891* (Oxford, 1991).

8 Letter, *c.* June–July 1884, in *Correspondance*, no. 93, 109.

9 Letter to Mme. L. Tapié de Céleyran, *c.* June–July 1884, in *Correspondance*, no. 94, 110.

10 It seems unlikely, given the context of the scene in which Toulouse-Lautrec faces the file of artists and others entering the „sacred grove," that he is urinating, as has been asserted. For succinct summaries of the varied interpretations of the *Parody* and the identity of various figures in it, see particularly Murray (note 7), 71–75, and Anne Rocquebert's entry in Thomson, ed. (note 2), 122–25.

11 *Correspondance*, no. 85, 104. The date of the letter is uncertain; 1879 (François Carco, *Nostalgie de Paris* [Geneva, 1965], 181), 1883 (Schimmel), 1884 (Roquebert), and — the most likely — about 1885/86 (Murray) have been suggested.

12 Letter to Mme. R. C. de Toulouse-Lautrec, 28 December 1886, in *Correspondance*, no. 137, 142.

13 Ibid.

14 Undated letter, spring 1886, in *Correspondance*, no. 127, 133.

15 Undated letters, spring 1886, in *Correspondance*, nos. 127, 133; 134, 141.

16 Joyant (note 1), II, 138, provides the basic identification. He does not identify Jane Avril or May Milton, whom he indeed misidentifies as „Mlle. Nelly C.," someone whose name is not otherwise associated with Toulouse-Lautrec, although in 1895 an English comedienne known as „Miss Nelly" appeared at the Moulin Rouge (Jacques Pessis and Jacques Crépineau, *The Moulin Rouge*, [New York, 1992], 46). The identification of May

Milton was first made by Charles Stuckey and Naomi Maurer in *Toulouse-Lautrec: Paintings*, exh. cat., The Art Institute of Chicago, (Chicago, 1979), 187, 247. For a further discussion of these identifications, see Heller, (note 2), 116–20. Thomson, ed. (note 2), 266–68, unconvincingly attempts to reject the identifications of both Jane Avril and May Milton.

17 Maurice Vaucaire, „Les Cafés-concerts," *Paris illustré*, no. 50 (August 1886), 138, as cited by Murray (note 7), 110–11. In addition to Murray's study, see Thomson, ed. (note 2), 238ff., on the *quadrille naturaliste* and Paris dance halls of the 1890s.

18 Alexandre Zévaès, *Aristide Bruant* (Paris, 1943), 36.

19 Aristide Bruant, „Marche des dos," *Dans la rue: Chansons et monologues*, I (Paris, 1889), 45–46.

20 „Casseur de gueules," in Bruant (note 19), I, 193.

21 There is a rapidly expanding literature on anarchism and French modernism. On Montmartre and anarchism, see particularly Richard D. Sonn, *Anarchism and Cultural Politics in Fin de Siècle Paris* (Lincoln, Neb., and London, 1989), and John G. Hutton, *Neo-Impressionism and the Search for Solid Ground* (Baton Rouge, and London, 1994). The pioneering study by Eugenia W. Herbert, *The Artist and Social Reform: France and Belgium, 1885–1898* (New Haven, 1961), remains indispensable.

22 Emile Henry, „A Terrorist's Defense," in *The Anarchist Reader*, ed. George Woodcock (Fontana, 1977), 193.

23 Paul Adam, „Eloge de Ravachol," *Les Entretiens politiques et littéraires* (July 1892), as cited in Henri Arvon, *L'Anarchisme au xxe siècle* (Paris, 1979), 107–08.

24 Jean Maitron, *Histoire du mouvement anarchiste en France (1880–1914)* (Paris, 1951), as cited by James Joll, *The Anarchists*, 2nd ed. (Cambridge, Mass., 1980), 117.

25 Pierre Quillard, „L'Anarchie par la littérature," *Les Entretiens politiques et littéraires* (April 1892), 149–51, as cited in Arvon (note 23), 179 and Herbert (note 21), 128–29.

26 Un impressioniste camarade [Paul Signac], „Impressionistes et révolutionaires," *La Révolte*, 13–19 June 1891, 3–4, as cited by Hutton (note 21), 251. A highly insightful reading of this text, on which my own comments depend, is provided by Martha Ward, *Pissarro, Neo-Impressionism and the Spaces of the Avant-Garde* (Chicago, 1996), 233–35.

27 Letter to his mother, July 1886, in *Correspondance*, no. 128, 102.

28 Felix Fénéon, „Tableaux," *La Vogue* (September 1889), as reprinted in Felix Fénéon, *Ouevres plus que complètes*, ed. Joan U. Halperin, I (Geneva, 1970), 166.

29 Ibid.

30 Pessis and Crépineau (note 16), 12.

31 Ibid.

32 Letter to Vincent van Gogh, 19 March 1890, in *Verzamlede brieven van Vincent van Gogh*, pt. IV (Amsterdam and Antwerp, 1974), Letter T29, 287.

33 E. de M., „Exposition des Indépendants," *La Liberté*, 21 March 1890. Martha Ward kindly furnished me with this reference.

34 [Anonymous], „Les Indépendents," *L'Art français*, no. 155 (12 March 1890).

35 „La Goulue," *Gil Blas* (1892).

36 [Félix Fénéon], „Henri de Toulouse-Lautrec et Charles Maurin," *L'Endehors*, 12 February 1893, in Fénéon (note 28), 215.

37 Letter to his mother, 25 January 1892, in *Correspondance*, no. 215, 187.

38 Arsène Alexandre, „Chroniques d'aujourd'hui: H. de Toulouse-Lautrec," *Le Paris*, 8 January 1892, as translated by Rhoda Miller in *Toulouse Lautrec: A Retrospective*, ed. Gale B. Murray (New York, 1992), 140–41.

39 „Chez les barbouilleurs: Les Affiches en couleur," *Le Père Peinard*, 30 April 1893, in Fénéon (note 36), 229–31.

40 Fénéon (note 36).

41 Alexandre (note 38).

42 Arsène Alexandre, „Celle qui danse," *L'Art français*, 29 July 1893, as translated in Murray (note 38), 161.

43 Wieland Barthelmess, „Zwischen Montmartre und Champs-Elysées: Pariser Vergnügungsetablissements und ihre Stars in den 1890er Jahren," in *Henri de Toulouse-Lautrec: Pariser Nächte*, exh. cat., Kunsthalle Bremen (Bremen, 1994), 20.

44 Alexandre (note 38).

45 Ibid.

46 Letter to his mother, *c.* December 1892, in *Correspondence*, no. 260, 211.

47 For a full discussion of evidence on the cutting and repair of the canvas, see Heller (note 2).

48 Joyant (note 1), I, 198–99.

49 Ibid.

50 Erich Klossowski, *Henri de Toulouse-Lautrec* vol. 15 of *Die Kunst*, ed. Richard Muther (Berlin, n.d.), 63.